Hogarth's Marriage A-la-Mode

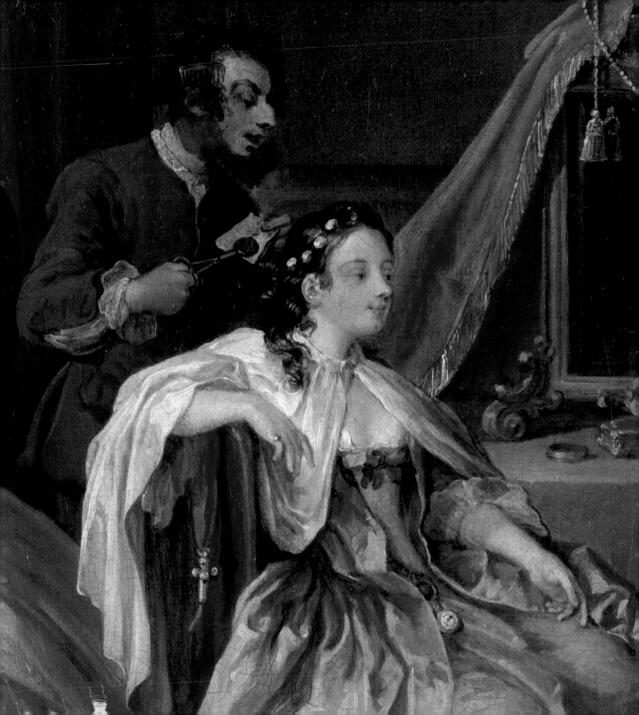

Written by JUDY EGERTON

Featuring a DVD narrated by ALAN BENNETT

Hogarth's
Marriage A-la-Mode

NATIONAL GALLERY COMPANY, LONDON
Distributed by Yale University Press

First published in 1997 to accompany an exhibition at the National Gallery,
London. Supported by the Bernard Sunley Charitable Foundation.

This redesigned edition published 2010
by National Gallery Company Limited
St Vincent House, 30 Orange Street, London WC2H 7HH
www.nationalgallery.co.uk

ISBN 978 1 85709 510 4
1018447

British Library Cataloguing-in-Publication Data.
A catalogue record is available from the British Library.
Library of Congress Control Number: 2010937531

Publishing Director Louise Rice
Publishing Manager Sara Purdy
Project Editor Giselle Osborne
Picture Researcher Suzanne Bosman
Design Joe Ewart for Society
Production Jane Hyne and Penny Le Tissier
Printed and bound in Hong Kong by Printing Express

National Gallery publications generate valuable revenue for the Gallery, to
ensure that future generations are able to enjoy the paintings as we do today.

Contents

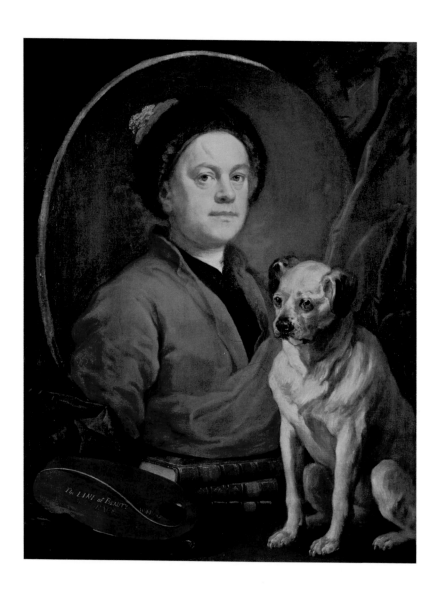

Introduction

Born in London in 1697, Hogarth started with few advantages except a lively mind, an exceptional visual memory and an irrepressible creative urge. He began at the lowest level of artistic work, engraving designs on silver, then set up his own business as an engraver on copper, engraving shop cards and book illustrations on copper plates. Hogarth's first independent print – that is, designed, engraved and published by himself – was *Masquerades and Operas*,[1] 1724. *The Masquerade Ticket* of 1727 (fig. 31) demonstrates how witty, inventive and skilful his engraved work was by the time he was 30.

As a painter, Hogarth began late, and had little formal training. In 1720, while working as a jobbing engraver, he enrolled at Vanderbank's Academy in St Martin's Lane, which was primarily a life class; but there, as at any other art academy of the day, he would have been taught that the highest form of art was history painting. He probably picked up some knowledge from Sir James Thornhill, the leading decorative painter, whose daughter he eloped with; but his painting methods were his own, and (like much of what he did) flew in the face of tradition. Instead of making preliminary sketches and studies for his paintings, he taught himself 'how Memory might be managed'; he found that he could 'make my studies and my pleasures go hand in hand by retaining in mind lineally such objects as fitted my purpose best'. So he set about painting the people and the teeming society around him. Hogarth seems to have had an innate gift for that 'lovely and

1 Opposite:
The Painter and his Pug, 1745.
Oil on canvas, 90 x 69.9 mm.
Tate, London, inv. N00112.

2 Above:
Louis François Roubiliac (1702–1762), *William Hogarth*, about 1741.
Terracotta bust, 71.1 cm high, including base.
National Portrait Gallery, London, NPG 121.

dainty use of paint'[2] which makes him one of the greatest of all British painters. He made his name as a painter in 1729 with a scene from *The Beggar's Opera* which led to many commissions for small portraits and conversation pieces. George Vertue reported in 1729 that 'MR Hogarths paintings gain every day so many admirers that happy are they that can get a picture of his painting'; and he observed that what distinguished Hogarth's portrait groups was not just that the 'likeness is observed truly' but that all his work was 'done with great spirit a lively invention & an universal agreeableness'.[3]

In rather fragmentary 'Autobiographical Notes' compiled towards the end of his life, Hogarth recounts a decision which was to be a turning point in his career, in time leading to the production of *Marriage A-la-Mode*. Painting portraits and conversation pieces had not proved profitable. 'I therefore turn[ed] my thoughts to still a more new way of proceeding, viz. painting and Engraving modern moral subjects a Field unbroke up in any Country or any age.'[4]

In designing fully elaborated pictorial narratives which enact a complete story of contemporary life, scene-by-scene, Hogarth created a new form of art.[5] The first of his 'modern moral subjects' was *A Harlot's Progress*, painted in six scenes in 1731, engraved by Hogarth himself and published in 1732, with great success. A contemporary noted that the 'Story' of the Harlot 'captivated the Minds of most People persons of all ranks & conditions from the greatest Quality to the meanest'.[6] It was followed by *A Rake's Progress* in eight scenes, engraved and published in 1735. Hogarth had by then established himself in Leicester Fields (now Leicester Square), at the sign of the Golden Head. During the next seven or eight years, he was chiefly occupied in painting portraits on the scale of life, such as *Captain Thomas Coram* (fig. 6) and *The Graham Children* (National Gallery, London). It was not until April 1743 that Hogarth announced his next 'modern moral subject': *Marriage A-la-Mode*, or *a Variety of Modern Occurrences in High-Life*.

The 'High Life' elements in *Marriage A-la-Mode* reflect Hogarth's observations – perhaps sharpened by the experience of painting conversation pieces for wealthy patrons – that people with money often have what he himself called 'bad taste', slavishly following fashions in dress and manners, preferring 'Masquerades and Operas' to good British plays, and affecting connoisseurship by buying copies of old masters instead of using their own judgement over works by living British artists. In *Taste in High Life* painted in 1742 (the engraving shown here in fig. 3), the principal characters are two exquisitely but absurdly dressed 'connoisseurs', both probably living on inherited wealth; an ecstatic but beady-eyed lady holds a tiny china cup, a ridiculous fop holds its (or perhaps a mis-fitting) saucer. In front of them an equally fashionably dressed and bewigged monkey peers at a menu combing French and English delicacies, including *cocks*

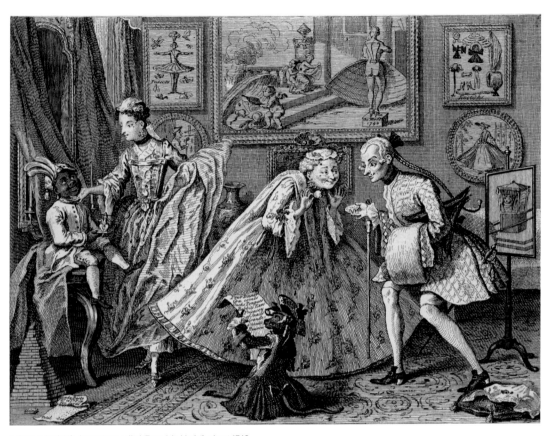

3 *Taste in High Life (sometimes called 'Taste à la Mode')*, about 1742.
Engraving, 20.5 x 26.3 cm.
Victoria and Albert Museum, London, inv. F.118:129.

combs, *ducks tongues* and *rabbit ears*. On the left, a younger lady in an unmanageable hooped skirt bestows a condescending hand to a small negro page whose presence in the scene itself epitomises a fashion in high society. A gambling debt of £300 is indicated by a bill on the floor. The pictures on the wall heighten this satire on fashion and folly; in the largest of them, the Venus de' Medici, a classic image of natural female beauty, is forced by fashion into the unnatural constraints of high-heeled shoes, stays and half a hooped skirt, allowing her to present a fashionable front to the world while showing how naturally beautiful she is from behind. *Taste in High Life* anticipates many of the themes in *Marriage A-la-Mode*, particularly in the way Hogarth uses 'pictures within the picture' to elaborate his meaning.

The 'moral' element in Hogarth's 'modern moral subjects' was heartfelt, but not exhortatory. He did not preach virtue; instead he satirised vice and folly. Elsewhere in his 'Autobiographical Notes' he refers to his designs as 'Comic and Moral'; and those linked adjectives accurately describe his own approach to life. Hogarth could never remain serious for very long; as Horace Walpole noted, 'the burlesque turn of his mind mixed itself with the most serious subjects'.[7] In calling Hogarth a 'Comic History Painter', Henry Fielding invented an entirely appropriate new category for his friend.[8]

Marriage A-la-Mode is one of the greatest and most original creations in British eighteenth-century art. In the form of the set of engravings published in 1745, it was instantly popular, both at home and abroad, and has never ceased to be reprinted or reproduced.[9] Hogarth the 'Comic History Painter' has continued to entertain (and perhaps to instruct) where many a more academically respectable History Painter has been forgotten. The primary works – the six paintings of *Marriage A-la-Mode*, which lightened the heart of the financier John Julius Angerstein and entered the National Gallery with the founding purchase of his collection in 1824 – are works of great beauty, painted with far more subtlety of colour than Hogarth's engravers would have needed to translate his designs into monochrome line. For subtle colour, one need instance only the ravishingly delicate colours of the Countess's dresses, or the play of firelight scene. Because the scenes are comic, it is easy to forget how finely observed and how beautifully painted they are, with a finesse not matched in Hogarth's earlier series.[10]

The six paintings of *Marriage A-la-Mode* are often considered to be Hogarth's masterpiece. Hogarth himself evidently knew that they were among the best things he had ever painted. His motive for offering them for sale in 1751 was presumably practical as much as financial: sets of paintings took up room, and he had already sold *A Harlot's Progress*, *A Rake's Progress* and *The Four Times of the Day*. The result of the sale of *Marriage A-la-Mode* to one of only two bidders (see pp. 70–1) was not merely disappointing but mortifying. 'This so mortified his high spirits & ambition that

[it] threw him into a rage [and he] cursd and damed the publick and swore that they had all combined together to oppose him ... and that day following he took down the Golden head that staid over his door.'[11]

The story depicted in *Marriage A-la-Mode* is a melodrama. When the curtain falls (as it were) on its last scene, not one of its characters has evoked a response as strong as our response to the natural vitality of *The Shrimp Girl* (National Gallery, London). But the story line is comparatively unimportant. The greatness of *Marriage A-la-Mode* lies in the fact that by sheer brilliance of design and inventive detail, Hogarth convinces us that we have witnessed a large part of the human spectrum, and alternately laughed and shaken our heads over it.

In six scenes, spanning perhaps two years, *Marriage A-la-Mode* shows how a marriage was made and wrecked. It is not a pretty story. It begins with a marriage arranged by two self-seeking fathers – a spendthrift nobleman who needs cash and a rich but plebeian Alderman of the City of London who wants to buy social status. The first scene introduces us to the five principal characters in the story: the Earl of Squander and his foolish son; the nameless Alderman and his headstrong daughter; and their unprincipled lawyer, named Silvertongue. Love between the bride and the bridegroom never develops; nor has either of them the wit to make the best of things. Instead, each pursues the nearest alternative form of pleasure, with disastrous consequences. The marriage which begins with money on the table ends with adultery, venereal disease, murder and suicide. The sole heir – a child in whose veins blue blood and riches were to have mingled for the worldly advancement of both families – ends up orphaned, crippled by disease and likely to die young.

Hogarth invented the characters, the settings and the plot of *Marriage A-la-Mode*, with a certain amount of 'hash and ragoo'[12] from various poems and plays, including those of his friend Henry Fielding. He did not of course invent his chief target – marriage for money rather than for love – which has provided a perennial theme for authors and playwrights at least from Philip Massinger's play *A New Way to Pay Old Debts* (probably first acted in 1625–6) to Anthony Trollope's *The Way We Live Now* (1875). Trollope's observation that 'Rank squanders money; trade makes it; – and then trade purchases rank by re-gilding its splendour' could serve as a summary of Scene 1 of *Marriage A-la-Mode*, painted well over a century earlier.

Hogarth may have begun work on the paintings of *Marriage A-la-Mode* in 1742; he worked on them steadily during 1743. From the start, he intended that the series should be engraved, so that prints could be made, published in sets and sold. Hogarth had himself engraved *A Harlot's Progress* and *A Rake's Progress*, both of which were 'low life' subjects. For *Marriage A-la-Mode*, set in 'High Life' and therefore demanding 'Elegancy', he decided to commission three highly skilled French engravers to work in London under

his direction (see 'Engraving *Marriage A-la-Mode*', pp. 70–1). Sets of the engravings were ready for subscribers by June 1745. They were quickly in demand; frequently reissued and reproduced, they have remained popular. Probably *Marriage A-la-Mode* is still best known in the form of the engravings, which are uncoloured and, like most reproductive engravings, in reverse direction to the paintings; but the paintings are incomparably more rewarding to look at.

With only six scenes, the plot is not always easy to follow, and some telling details are easily overlooked. Various commentaries on *Marriage A-la-Mode* have been published, from André Rouquet's *Explication* of 1746, the year after the prints were published, to the present day, all seeking to explain 'the multiplicity of little incidents, not essential to, but always heightening the principal action'.[13] Almost all of them are based on the uncoloured engravings rather than on the paintings themselves. Interpretations differ, understandably, for *Marriage A-la-Mode* is not a verifiable account of real occurrences but a comic fiction invented by a quicksilver mind; equally understandably, most accounts (including this one) are to some extent repetitive, as each writer builds on another's observations. The scene-by-scene account offered here is based on the paintings, whose colour is continually inventive and subtle; this allows for some fresh observations. There can be no single authoritative explanation, nor is it likely that the last word will ever be said about *Marriage A-la-Mode*.

Hogarth's wit has fairly been called penetrating, mordant, even savage. These are the proper characteristics of the satirist. Perhaps because his work is best known in the form of line engravings, Hogarth is often called a caricaturist, but he is more that that. His etching *Characters and Caricaturas* (fig. 4),[14] issued as a form of receipt to advance subscribers to the prints of *Marriage A-la-Mode*, was designed to demonstrate the infinite variety of facial expressions with which an artist could suggest character without resorting to the 'distortions and exaggerations' of caricature. Throughout *Marriage A-la-Mode*, Hogarth displays wit of a high order. That wit is first and foremost based on his observations of contemporary life; but is laced with two pungent ingredients, less obviously visible. One is his dislike of foreign (and particularly French) airs and graces, which he described as 'a foppish kind [of] splendoure sufficient to dazzle the eyes of us Islanders and draw vast sums of money from this country'.[15] The other is a genius for alluding in paint to a variety of home truths, old proverbs and current slang expressions, which contemporaries would have understood well enough, but which now need some explanation. One example must suffice at this point. In the first scene, as has long been recognised, the coupling collars worn by the foxhound and bitch in the foreground anticipate the bonds of matrimony which will soon couple the unwilling bride and bridegroom. The image is given extra force when

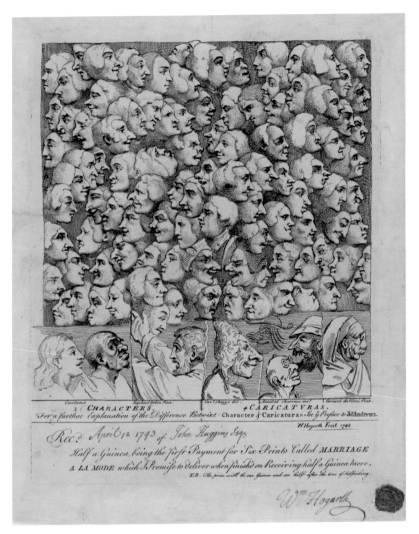

4 *Characters and Caricaturas*, 1743.
Etching and engraving, 26 x 20.5 cm.
The British Museum, London, inv. 1848,1125.209.

we know that in the slang of the day, 'persons chained together in order to be conveyed to gaol are said to be married'.[16]

Marriage A-la-Mode is an intricate story with a large cast of minor characters. It is also includes innumerable details which contribute to the story's meaning. These are to be found not only in the faces, gestures and manners of the characters (the age-old way of story-telling through pictures), but also in the furniture, *objects d'art*, and above all the 'pictures within the pictures'. Hogarth's 'backgrounds' are anything but neutral; they play a positive role in each scene. As Horace Walpole observed, 'The very furniture of his rooms describe the characters of the persons to whom they belong.'[17]

In printed *Proposals* dated 25 January 1745, Hogarth announced that he would sell 'the Six pictures call'd *Marriage A-la-Mode*' (although in fact he did not offer them for sale until 1751, see pp. 70–1). His *Proposals* are noted here because they include the only record of the titles which Hogarth himself gave to the six scenes in *Marriage A-la-Mode*, as follows (fig. 5):

1. *The Marriage Settlement*
2. *The Tête à Tête*
3. *The Inspection*
4. *The Toilette*
5. *The Bagnio*
6. *The Lady's Death*

Over the years, many variations of these titles have been used; but those given above are Hogarth's own titles for the paintings, and should be respected. The engravings do not have individual titles; each carries the general title *Marriage A-la-Mode*, followed by Plate numbers I–VI.

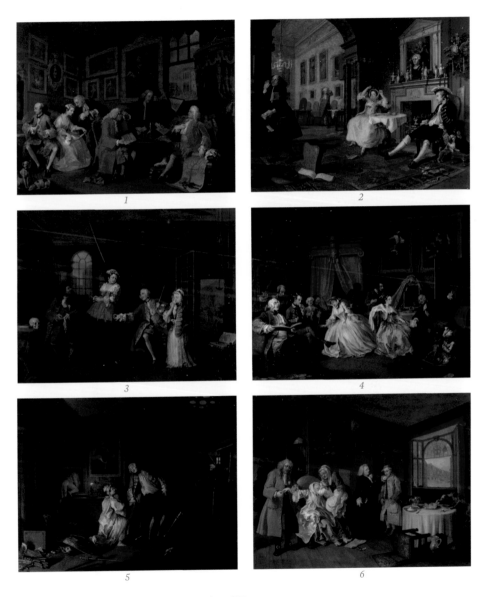

5 The complete series of *Marriage A-la-Mode*, 1–6, about 1743.

1: *The Marriage Settlement*

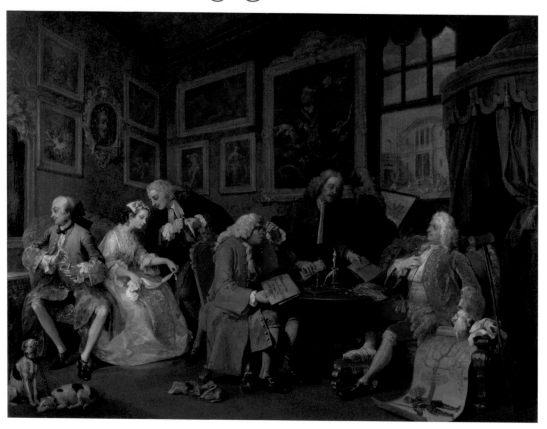

The scene is the Earl of Squander's bedroom in his town house; but this is no ordinary levée. The pivot of the scene, dead centre, is a bulky parchment document lettered *Marriage Settlem^t of the Rt Hon^ble the Lord Viscount...* [*Squanderfield* is added in the engraving]. The Earl of Squander (father of the bridegroom) and the Alderman (father of the bride) are still haggling over it, while the bride and bridegroom, pawns in a game which is none of their making, sit unhappily by.

Lord Squander has the blue blood of centuries in his veins, or so proud manner asserts. He points to a family tree which traces descent from the bowels of William the Conqueror, but it looks distinctly bogus, and the opportunities he seizes to display his coronet – behind him on the top of his bed canopy, opposite him on top of a wall sconce, on his footstool and even on the arm-rests of his crutches – are more like the vulgarity of a *parvenu*. Rouquet, the earliest interpreter of these scenes, remarked that one can almost hear this proud egoist say: 'Moi, mes armes, mes titres, ma maison, mes ancêtres.'[18] Lord Squander is in every way the antithesis of the unselfish (and unfashionable) Captain Coram, founder of the Foundling Hospital, whose portrait Hogarth had painted in 1740 (fig. 6).

Lord Squander would be still haughtier if he could, but is handicapped by gout. One clumsily bandaged foot markedly detracts from his extravagant if slightly old-fashioned style of court dress (rose coloured velvet frock-coat thickly trimmed with gold lace, over a tinselled waistcoat

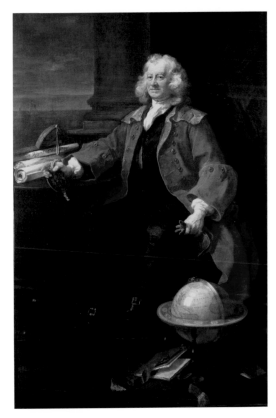

6 *Captain Thomas Coram*, 1740.
Oil on canvas, 236.3 x 145.8 cm.
Thomas Coram Foundation, London.

whose lavish lappets of gold braid almost defy description). Other unpleasant facts exert their pressures on him. Outside the open window is a glimpse of the new, grandiose house which he has ordered (oblivious of the fact that it breaks all rules of architecture); though it is still under scaffolding, it is already mortgaged as papers on the table show. Work on it has come to a standstill for lack of money, and workmen idle on the site. The Earl's lawyer, who should be attending to the business in hand, looks out of the window, holding *A Plan of the New Building of ye Right Hon Earl...*, and perhaps calculating by how much he can increase his fees once the Earl is in funds. But what the Earl most urgently needs is ready money.

All he can now hope to do is to stare the Alderman down. That is not so easy as it might appear. The Alderman, uneasily seated in a chair surmounted (of course) by a coronet, cuts an inelegant figure in his plain and serviceable broadcloth coat and blue breeches; he does not know how to behave in society (he is probably committing some breach of etiquette by wearing his chain of office on a private occasion), and he clearly does not know what to do with his sword, which pokes out at a ludicrous angle between his calves. But although he may look as thick as 'a post in his warehouse',[19] he is shrewd. Peering through his spectacles, he assesses what's on the table. Lord Squander will get his ready money – golden guineas lie there, emptied from money-bags on the floor (but one coin has been 'overlooked') – and the

7 The bride and her lover, Silvertongue: detail from *The Marriage Settlement.*

redemption of his mortgage, now held out to him by the Alderman's clerk, with other redeemed bills. (Note the three pins in the aged clerk's sleeve; a true servant of his master, he has evidently been brought up to believe that 'A Pin a Day is a Groat a Year'.[20]) Presumably a vast allowance for the Viscount constitutes the major part of the marriage settlement. The Alderman believes that he is buying into the ancient aristocracy; but here he is taking a risk very different from his usual form of trading, with so far nothing to prove the equation of blue blood and ready money. That is why he havers, hesitant to sign. Inkstand and quill are ready on the table, with a candle to melt the wax whereby the settlement once signed can be sealed. Any minute now the bargain should be concluded.

To the Alderman's daughter and the Earl's son (figs. 7 and 8), these negotiations over a marriage that neither of them wants must seem as if they had been going on for ever. The bridegroom, at present called Lord Squanderfield,[21] will succeed as the next Earl of Squander when his father dies; but that is the only thing he is ever likely to succeed in or at. Foppish and foolish, he is exquisitely dressed in the latest French fashion, down to the red heels of his shoes. His father may well have sent him off on the Grand Tour to acquire some *savoir-faire*; but the Viscount (like many others) is unlikely to have got beyond the tailors, perruque-makers and fleshpots of Paris. He does not in the least resemble the Earl, his father, who for all his faults is canny and combative. The Viscount instead has the dazed and

8 Viscount Squanderfield: detail from *The Marriage Settlement.*

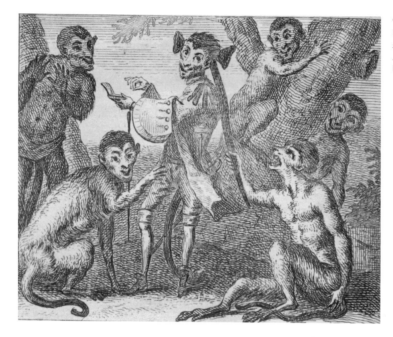

9 John Wootton (1682–1764), engraved by G. Vandergucht, *The Monkey who had seen the World*, illustration to no. XIV of John Gay's *Fables*, 1746 edn. Private collection.

satiated look of *The Monkey who had seen the World* (fig. 9), in John Wootton's illustration to one of the *Fables* of Hogarth's great friend John Gay, first published in 1727. Not overburdened with brain, pursuing pleasures of the most superficial kind, he is in many ways the most straightforward character in *Marriage A-la-Mode*. While the two fathers haggle, he takes a pinch of snuff and contemplates his own image in a looking-glass hanging over a console table (the latter adorned with yet another coronet). He, and his assumed ability to beget further aristocrats, is what his future father-in-law is buying. But the Alderman, shrewd enough over money, has failed to take account of a large black spot on the Viscount's neck. It might just pass for a beauty spot; but the black spot is in fact Hogarth's symbol for those who are taking the black mercurial pills which at the time were the only known treatment for venereal disease.[22] The black spot will continue to be the Viscount's most conspicuous attribute, though it will appear on others as well. It alerts us from the very start of Scene 1 to a dark motif which is to run throughout *Marriage A-la-Mode*.

Sullen and mutinous in her wedding finery, distractedly shuttling a gold ring along the veil she will have to wear for the ceremony, the bride sits next to him. Equal victims of their fathers' dealings, they neither care for nor look at each other. Below them on the floor, two foxhounds – already 'married' by a coupling collar – parody their roles. The Alderman's black-gowned lawyer takes advantage of his position in the background to lean familiarly over the girl. This is unlikely to be their first meeting. Horace Walpole detected two centuries ago that in *Marriage A-la-Mode* 'an intrigue [is] carried on throughout the piece',[23] that is, right from the start. If the girl and the lawyer are not lovers, they soon will be. The lawyer has neither money nor breeding: the Alderman would never consent to his daughter marrying him. We learn later that the lawyer has the odd name of Silvertongue. Hogarth's contemporaries would have recognised the allusion to the proverb: 'A man that hath no money in his purse must have silver in his tongue.'[24] Silvertongue must rely on charm to keep the 'intrigue' going. This he does, up to the penultimate scene. And the girl remains loyal to him throughout. It is to her credit that in this scene she is not swayed by the prospect of rank and riches – unlike Miss Sterling in *The Clandestine Marriage*, who longs for marriage to a lord: 'Oh, how I long to be transported to the dear regions of Grosvenor-Square – far, far from the dull districts of Aldersgate, Cheap, Candlewick and Farringdon Without and Within! – My heart goes pit-a-pat at

10 The portrait of Lord Squander as a hero of war: detail from *The Marriage Settlement*.

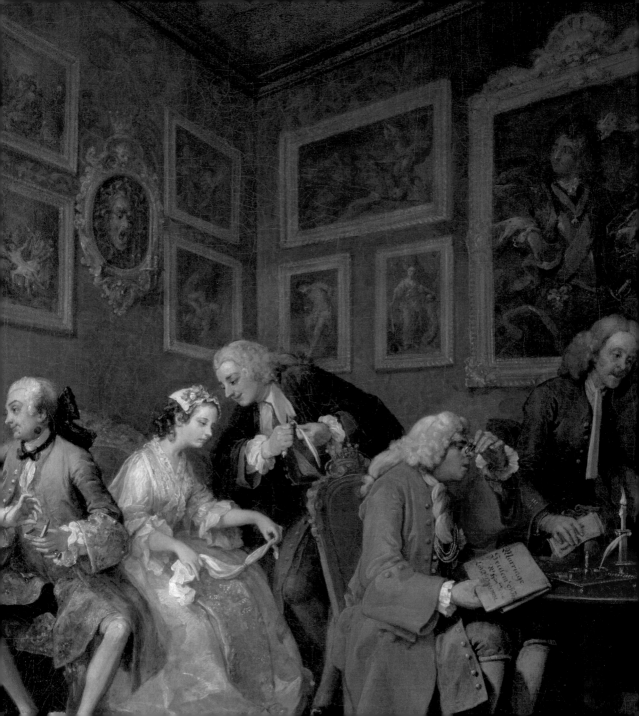

the very idea of being introduced at Court! – gilt chariot! pyeballed horses! – laced liveries!'[25] *The Clandestine Marriage*, a play by George Colman and David Garrick first performed at Covent Garden Theatre in 1766, was chiefly inspired by *Marriage A-la-Mode*, though its plot is rather different. In its *Prologue*, Garrick declaimed:

> *Tonight, your matchless Hogarth gives the thought,*
> *Which from his Canvas to the Stage is brought.*
> *And who so fit to warm the Poet's Mind,*
> *As he who pictur'd Morals and Mankind?*

The pictures on the walls of Lord Squander's house make their own comment on events. They are almost all copies of 'dark old masters', of the kind which (to Hogarth's disgust) 'connoisseurs' liked to buy while disdaining the work of contemporary British artists (fig. 11). *Medusa* (after Caravaggio), inset into a wall sconce hanging over the bride, sets the tone: screaming, with vipers writhing in her hair, she gives vent to rage; the bride may wish she could do the same. She may even feel that the martyrdoms depicted on *Medusa's* right – *Saint Lawrence* (after Le Sueur) roasted over burning coals and *Saint Agnes* (after Domenichino) forced to enter a brothel before finally having her throat cut – are as nothing compared to her fate. In Silvertongue's corner, aggression largely takes over from martyrdom,

warning us that he may turn nasty. To the left of his head, *Cain slaying Abel* (after Titian) is a bad omen for the events of Scene 5, while above it *Tityus and the Vulture* (after Titian) is more straightforwardly horrible. On the window wall, *David killing Goliath* (a third 'Titian') hangs above two smaller pictures. Hogarth may have invented the picture of Saint Sebastian pierced with arrows as a visual pun on Silvertongue, pierced with lust and sharpening his quill. Guido Reni's *Judith with the Head of Holofernes* completes this group, allowing us to admire the largest painting of all. This appears to be a portrait of Lord Squander himself, by a French artist of the most flamboyant school of portraiture (fig. 10). Here Hogarth seizes the chance to mock the style of contemporary French portraitists such as Hyacinthe Rigaud and Nicolas de Largillière. The portrait depicts the Earl in his younger days as a conquering hero in cuirass and tremulously fluttering sash, half-General, half-Jupiter, with a thunderbolt in his hand and wearing round his neck the Order of the Golden Fleece, an honour awarded to no Englishman between Henry VIII and the Duke of Wellington.[26] For all the appurtenances of glory, the sitter has an unmistakably shifty look, recalling no one so much as Ancient Pistol in Shakespeare's *Henry V*, who kept out of the thick of the Battle of Agincourt and told post-war lies about his exploits. Mistrust about the Order of the Golden fleece around the painted Earl's neck can only add to our doubts about the credibility of his family tree.

2: The Tête à Tête

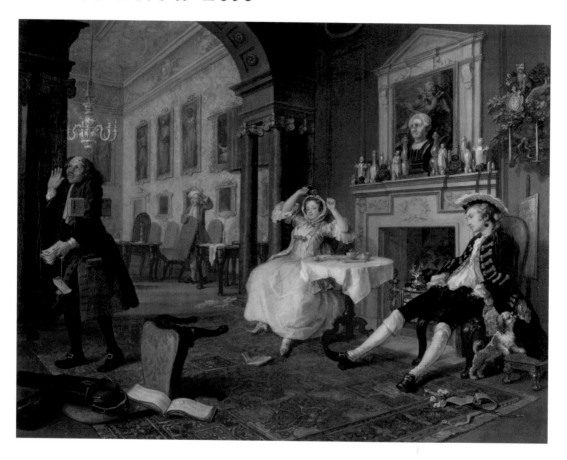

Some months after the marriage. The phrase 'Tête à Tête' implies a private conversation with no third party present: in Dr Johnson's *Dictionary* it is rendered as 'cheek by jowl'. The scene is the double drawing room in the house we saw out of the window in Scene 1, now completed with the Alderman's money, and as badly designed within as without. A Viscount's coronet surmounting the chandelier tells us that the old Earl must still be alive; but he does not reappear, and the Viscount will soon succeed as the next Earl of Squander.

A wall-clock shows the time to be about 12.20, or shortly after noon. The Viscount has been out on the town and has come home much the worse for it. The pose he affected in Scene 1 was mannered and unnatural; now he sprawls in his chair in an attitude which is graceless and all too natural. A poodle sniffing at his coat pocket detects one cause: stuffed into that pocket is a girl's muslin cap, much like the one hanging on the bed-curtain in *Before* and *After* (fig. 12), whose one-word titles suffice to tell their story. Another feminine trophy is wrapped around the hilt of the Viscount's sword. Comparison with a painting of about 1730 by Jean-François de Troy (fig. 14) suggests that this is a trick he learnt in France. But the Viscount's sword is broken. How he succeeded in breaking it we don't know and he will be unable to recall, but it can't have been in combat, since the sword is still in its scabbard. Pallid, his eyes glazed, the black spot on his neck now even more conspicuous, the Viscount is in no state for conversation, private or

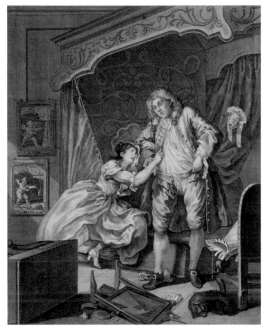

12 *After*, 1736.
Etching and engraving, 41 x 32.8 cm.
Andrew Edmunds, London.

otherwise. Any minute now he will simply pass out.

There is nothing simple about his wife's expression, as she stretches, seemingly half-awake, from the other side of a portable table laid with breakfast for one. With half-closed eyes, she takes in the evidence of her husband's debaucheries. They don't seem to disconcert her; by now she is probably used to them. The evidence in the room is usually taken to suggest that her own evening passed agreeably: playing cards lie on the floor, with a copy of *Hoyle on Whist*,[27] two violins in their cases and a music-book: what could be more innocent?

But everything about the wife tells us that she has a secret of her own which enables her to regard her husband with an air of sly triumph. Even her fashionable shoes turn upwards with extra impudence. The manner in which she thrusts her body forward as she stretches is usually taken to indicate that she is pregnant. If so, the child is probably her husband's; but we cannot be certain she is faithful to him. Several details suggest that it may well have been Silvertongue who was here with her last night, and has perhaps been a regular visitor; he may still be concealed somewhere in the house. Look at the carving on the side of the chimneypiece, just level with her left cheek: it is the head of a man, suggesting a third party in the marital *tête à tête* (fig. 13). It has previously escaped notice, probably because it is less conspicuous in the engraving. Of course the head could be an incidental flourish in the woodwork; but little is incidental in Hogarth, though much is ambiguous. There is no matching head on

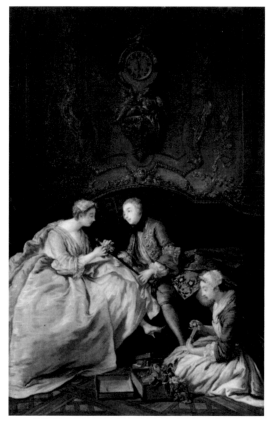

14 Jean-François de Troy (1679–1752), *Tying a Ribbon on a Lover's Sword*, about 1730.
Oil on canvas, 64.8 x 45.7 cm.
Private collection.

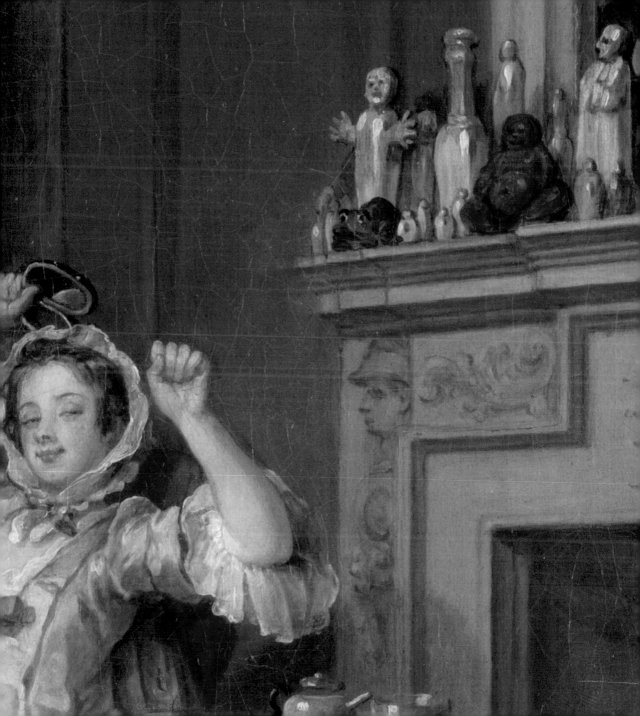

15 Charles-Nicolas Cochin (1715–1790), *A Party of Revellers*, 1738. Red chalk, 24.6 x 33.3 cm.
Ashmolean Museum, Oxford, inv. WA 1863.90.

Hogarth probably borrowed from this for the Viscount's pose in *The Tête à Tête*.

the other side of this otherwise symmetrical chimneypiece, and Hogarth has depicted a head in a chimneypiece for purposes of his own before this.[28] Something is reflected in the small folding pocket mirror which she raises in her right hand: it is unlikely to be her tea-cup. Can she be signalling to someone whom we do not see? The picture hanging high up in the further room behind a partly drawn curtain also seems to be telling us that something clandestine is or has been going on. Originally Hogarth painted a 'Madonna and Child' within this frame; but all that can now be seen in it is a large bare foot, belonging to somebody lying down, and presumably engaged in an activity so indecent that the picture has to be largely concealed.

Evidence of a whist party the night before is in fact slight: one small pile of cards, a book which may not have been consulted and a chair which has certainly not been overturned in excitement over a game of whist. But two fiddles in cases – one case open, revealing the fiddle's base and tailpiece – lie on top of each other in a manner which suggests sexual innuendo. The open music book is one of the most tantalising objects in this scene. The tune transcribed in it may be the tune of a popular song whose words might provide further clues to the whole scene. It is perfectly playable; but so far it has eluded all attempts at identification.

A cherub in the painting inset in the elaborate chimneypiece is playing a different tune, and playing it on the bagpipes. We know that this tune is called *Oh happy groves* (a song about once-happy

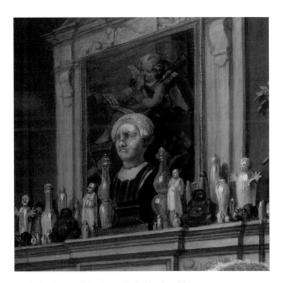

days when 'all was love'),[29] since its title is lettered on the cherub's music. Here Hogarth mocks in paint what he also mocked in words: the tendency for old masters to represent heaven as full of cherubs and putti, with 'swarms of these little inconsistent objects, flying about'.[30] A cherub playing the bagpipes sets the tone for the whole ludicrous assemblage of *objets d'art* around it. The badly proportioned chimneypiece itself is often said to be a satire on the designs of William Kent, the most fashionable interior designer of his day, whom Hogarth disliked; but it does not resemble any of Kent's published designs, and there is nothing specifically Kentian about the room.

The Squanderfields have bad taste; that is the message of the objects in this room. Take the mantelshelf: at first sight, its clutter of 'old' looking collectables looks quite prestigious (fig. 16). In the middle is an ancient bust with a broken nose, which might suggest a decent veneration for classical antiquity; but grouped around it is a truly awful collection of fashionable but bogus chinoiseries: 'squatting, round-bellied, open-mouthed orientals made in imitation, or rather in travesty, of Chinese images of Pu-Tai, the god of happiness'.[31] These 'pagods', or pagoda figures, were all the rage in the 1740s. Hogarth, who considered the 'pagods of China' to be absolutely void of elegance,[32] has piled them up on the Squanderfields' mantelshelf. A couple of baleful jade toads and some bulbous glass complete the ensemble.

Next to the chimneypiece is a wall clock of

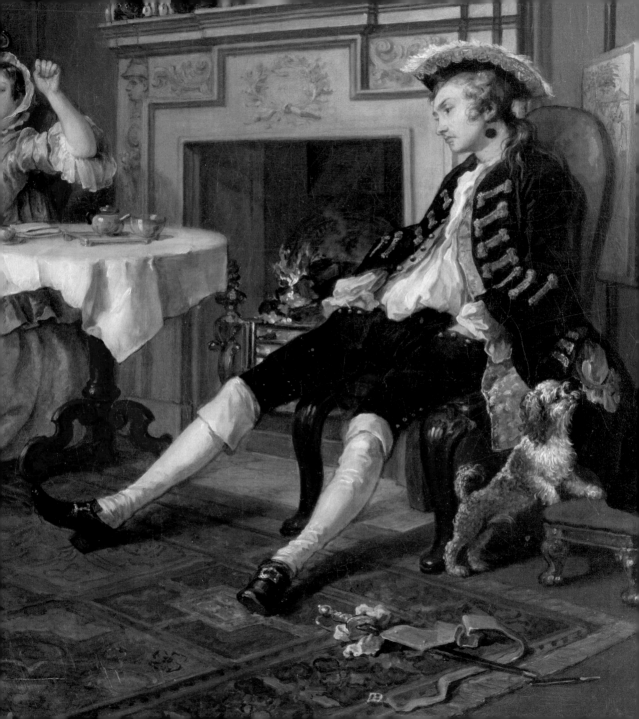

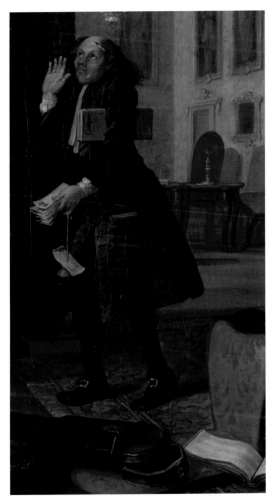

18 Exit of the self-righteous steward: detail from *The Tête à Tête*.

nightmarish fantasy; without parallel in the history of clock-making, it can only have been made to Lady Squanderfield's whim. The clock is set off-centre in metallic foliage on which a cat perches, a fish swims and a Buddha squats, extruding a pair of twisted candle holders from his loins. Whether or not the clock is telling the right time is problematic: in a disorderly household like this, who would remember to wind it?

In the further room, a slovenly footman who should be putting things to rights merely shambles about, yawning, still in his hair-curlers. The three tall paintings are of saints Matthew, Andrew and John the Evangelist, who would have been happier company if the painted-out 'Madonna and Child' had been left alone. No pictures have been painted in the lower four frames.

Exiting left, the steward of the household (fig. 18) says it all, rolling his eyes towards heaven. With his *Ledger* under his arm and a stack of unpaid bills in his hand, he has come to 'help' his master; but his master is in no fit state to settle accounts. So the steward leaves, self-righteously, with a tract lettered *Regeneration* (the title of one of the Revd George Whitefield's most popular Methodist sermons) sticking out of his coat pocket so that all shall know that he is a godly man. Dangling from his little finger is a spike with a single piece of paper on it; this paper is inscribed *Rec^d* 1743, thus nearly recording the date of the painting itself.[33]

3: *The Inspection*

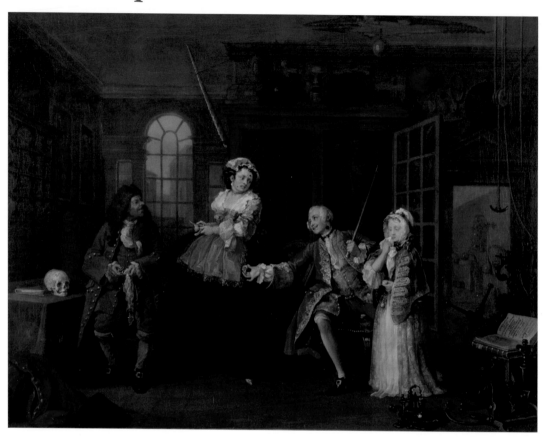

The scene is a doctor's consulting room. The Viscount has evidently been here before. This time he is accompanied by a very young girl. The manner in which the Viscount sits (sideways) on a chair at once suggests at least four things: that he is the principal patient; that the pill box placed near his groin contains pills previously prescribed for venereal disease; that the very young girl standing in the space between his outstretched legs is (at least temporarily) 'his' young girl; and that since he sits while she stands, she is decidedly his social inferior.

Brandishing his cane, the Viscount appears to be protesting that the doctor's pills don't work. They haven't cured him; and now the young girl appears to be infected with the same disease. She too holds a pill box in one hand; with the other she dabs at what may be a syphilitic rash near her mouth. The Viscount lacks the imperiousness of the old Earl; we can almost hear him saying 'Now look here ...', but in an ineffectual rather than menacing way.

While he blusters, we can look more closely at the pills. They are quite clearly black. The principal treatment for venereal disease at this time was a concoction of mercury, made up into pills. Hogarth's black spots are the symbols of the black mercurial pills which some of his characters take because they are infected with the disease. Elaborate efforts in the past to explain the meaning of this scene, and in particular to puzzle out why

20 The doctor and the skull: detail from *The Inspection*.

Hogarth should have included *three* pill boxes (fig. 19), overlook the simple pictorial device of links in a chain of cause and effect: the box by the Viscount's groin indicates the source of his disorder, the box he himself holds indicates his need for further treatment for his infection, and the box the young girl holds suggest that through him she too has become infected. Venereal disease was rife in this period, and easily caught. Most 'cures' had unpleasant side-effects ('Two minutes with Venus: two years with mercury'[34] was a lesson many learnt painfully), and not all were effective. Doctors all over London openly advertised their pills for this 'disorder', usually on the back pages of newspapers, where Hogarth's and other artists' advertisements for the publication of engravings might also be found.

The doctor polishes his spectacles on what must be the most disgusting handkerchief in the whole of British art. He has generally been assumed to be a figure of fun, made laughably hideous to undermine his pretensions and to show that he is a 'quack doctor'. But Hogarth himself did not call him that. The most noticeable thing about the doctor is that he himself is riddled with venereal disease (fig. 20). This has escaped the notice of art historians, but not that of medical men.[35] The doctor's face, and particularly the sunken bridge of his nose, his bulging forehead, thick lips and probable toothlessness, are characteristics of the 'bulldog facies' of an advanced degree of congenital syphilis, as are his deformed legs, bowed or 'sabred'.[36]

21 Rembrandt (1606–1669), *Portrait of Gérard de Lairesse*, 1665. Oil on canvas, 112.7 x 87.6 cm.
The Metropolitan Museum of Art, New York.
Robert Lehman Collection, 1975, inv. 1975.1.140.

A portrait by Rembrandt of the painter Gérard de Lairesse in 1665 (fig. 21) illustrates the typical 'dish face' of a fellow sufferer. 'Physician, heal thyself' is useless counsel here. On a table beside the doctor is a human skull, not in itself a surprising object for a medical man to keep, perhaps for demonstration purposes. But this skull is riddled with small black holes which indicate syphilitic erosions. The long and not always helpful anonymous poem about the six scenes written in 1746 'in Hudibrastic verse' is at least to the point on the subject of the skull:

> *And tho' it was extremely thick*
> *The p-x ten holes did in it pick.*

There is also a virago in the room, and a positively threatening one (fig. 22). She was once a fine figure of a woman, and is still quite handsome, despite two tell-tale black spots on her face (every human being in this room, as well as the once-human skull, is infected to some degree with venereal disease). Even more tell-tale is the tattoo FC above her left breast, said to have been inflicted on convicted prostitutes[37] (the letters are now difficult to see in the painting, but are fairly clear in the engraving). As the Viscount brandishes his cane, she is ready with a weapon of her own: a vicious-looking knife of the type which might be used in a doctor's surgery for blood-letting.

The woman's seeming fury, and her relationship (if any) to the other three people in this room, have puzzled previous commentators. She has been variously supposed to be the doctor's mistress, indignant at criticism of the efficacy of his pills, and/or the manageress of the establishment's sideline, who has procured the young girl for the Viscount and now appears to be furious that one of her girls should have been brought back infected with his disease.

She may well be both these things: but if one looks at the painting rather than the engraving of this scene, colour is a positive aid to interpretation. Hogarth has provided an unmistakable clue to the fact that the relationship between the furious woman and the seemingly helpless young girl is one of mother and daughter. The girl's skirt is of an unusual material, patterned with red flowers on a gold background. The woman's sleeves are of exactly the same material, suggesting that she has used remnants of an old gown to make a skirt for her daughter and a bodice for herself. Hogarth's attention to detail was meticulous; he would never have repeated the same fabric on two figures in the same scene if he had not wanted to tell us of a relationship between them. He is in fact deliberately informing us that the woman is the girl's mother. There is a further implication of 'Like mother, like daughter', an adage as old as the Book of Ezekiel:[38] the girl is already following her mother's career. That a mother should put her young daughter out to prostitution was all too common in this period. The Viscount is unlikely to be the girl's first client. Who gave her the pox – if indeed she has the pox and is not just acting, like her mother – cannot be certain;

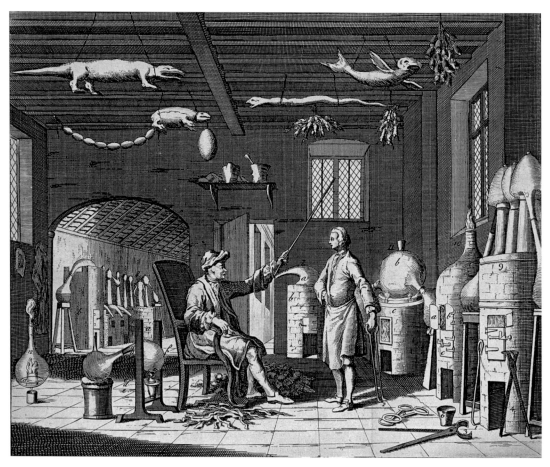

23 Anon, *A Second View of Practical Chemistry*, engraved in the *Universal Magazine*, 1747.
Engraving.
The Wellcome Trust, London.

but it looks as if this may not be a pathetic scene of innocence wronged but a carefully rehearsed scene in which the Viscount will end up paying handsome damages for uncertain responsibility.

Hogarth entitled this scene *The Inspection*; but his own titles were soon forgotten, and this scene came to be known as *The Visit to the Quack Doctor*. Some unpleasant-looking iron machinery on the right immediately arouses the sort of apprehension felt on entering a doctor's surgery; the pulleys above do nothing to allay it. The title page of an open volume – *EXPLICATION/DE DEUX MACHINES SUPERBES: L'UN POUR REMETTRE/LES EPAULES/L'AUTRE POUR SERVIR DE TIRE-BOUCHON* – tells us that one of these machines is for setting shoulders; the other is for drawing corks. The title page informs us that the machines are the invention of *MONSR DE LA PILLULE*, and that both have been approved by the Royal Academy of Sciences in Paris. Facing the title page is an engraved portrait of M. de la Pillule,[39] the author and inventor; presumably this is a portrait of our doctor, in better days. The evidence in the room establishes that the doctor practises simultaneously as physician, surgeon, barber-surgeon, apothecary and chemist; an open door on the right offers a glimpse of his distilling room. Shelves against the left wall are lined with jars containing drugs, identified by labels; beneath them are drawers of herbs used to make up the drugs. So far, these are standard equipment. Beyond the shelves are two pictures of *lusus naturae*, commonly known as freaks: one is a

man with his head growing below his shoulders, the other appears to be a double-headed hermaphrodite. Below them are the squat figures of two painted mummy cases, of no known medical significance, but sought after by collectors in the 1740s. If the objects on the left wall are odd, those on the end wall are bizarre. A handsome cabinet, of the type used by more erudite collectors as a cabinet of curiosities, occupies most of the wall. Slung from it, on the left, is a narwhal horn, about five feet long. On top of the cabinet and on the wall beyond it are ranged – more or less in this order – a pile of bricks (perhaps to be heated to allay pain); a barber's shaving bowl; a conspicuously large urine flask; a head of the sort which might hang outside an apothecary's shop, with a pill in its movable jaw; a giant's femur, hanging behind it; a small (but significant) tripod; an ivory comb, perhaps Eskimo (or Lapp); a tall hat, possibly North American, and a pair of moccasins; an outsize spur, with a stuffed reptile below it; an ancient long-handled sword and buckler; and a dark picture of a malformed child. Presiding over all this is a stuffed crocodile which has produced an ostrich egg. Since Thomas Wyck's paintings of alchemists in the 1670s, popular images of scientists invariably included at least one flying reptile (there are several in fig. 23). Hogarth probably borrowed his crocodile volant from William Kent's illustration to *The Pin and Needle*, no. XVI of Gay's *Fables*, 1727, which also includes a 'philosopher' flourishing a staff; but Hogarth turns the wise man's staff into a cane, and (paradoxically) allots it to the foolish Viscount.

Many of these strange objects could be matched in the 'cabinets of curiosities' formed by men far more eminent than this doctor. Such objects testified to their owners' intellectual curiosity. Dr Richard Mead, physician to George II and one of the most learned men of his day, had several 'walnut tree cabinets' full of curious items; it took a five-day sale to disperse them.[40] He owned 'an Egyptian mummy, well preserved, with its original coffin', numerous 'serpents [pickled] in glasses', 'a monstrous embryo of a hog with 8 legs', a crocodile or two and a narwhal horn six-and-a-half feet long, as well as an even greater curiosity, the double horn of a rhinoceros. But as a connoisseur, Dr Mead owned things of beauty which this doctor could never aspire to: antique sculpture, carved gems and two paintings by Watteau, his patient in 1719–20.[41] Hogarth respected Dr Mead, knew his collection and would have had no wish to make fun of it; but he may have picked out some of the more commonplace objects in it to furnish this room. What this doctor most

conspicuously lacks is evidence of learning. A truly learned physician would have had shelves full of books; here, apart from the doctor's own treatise, there are none.

One of the cabinet doors has swung open, to reveal a skeleton, an *écorché* (the sculptured figure of a man whose muscles and tendons are exposed as if the covering skin had been removed) and a periwig on a wig-makers' block and pole (fig. 24). A skeleton and an *écorché* figure can be of value for teaching purposes, and were often found in anatomy theatres ('a skeleton in one niche and an *écorché* in an answering niche').[42] But these two, though certainly dead, are not quite. The skeleton is making advances to the *écorché*, one bony hand between its legs; the *écorché*, open-eyed and with far more expression in its face than such a figure would normally have, seems uncertain how to respond.[43] The tripod (mentioned above) seems to be placed directly over the *écorché*'s head: is it an omen of the three-sided gallows tree whose shadow is to loom over the last scene? The face on the wig block[44] seems to watch not only what is going on in the cabinet but the goings-on in the room itself. This may be a less than reverential portrait of the late Dr John Misaubin (died 1734), who specialised in the treatment of venereal disease with pills of his own concoction. Henry Fielding dedicated his play *The Mock Doctor* (first performed in 1732) to Dr Misaubin, with mock-reverence, for 'that Little Pill' which had rendered him 'so great a blessing to mankind'.[45]

4: *The Toilette*

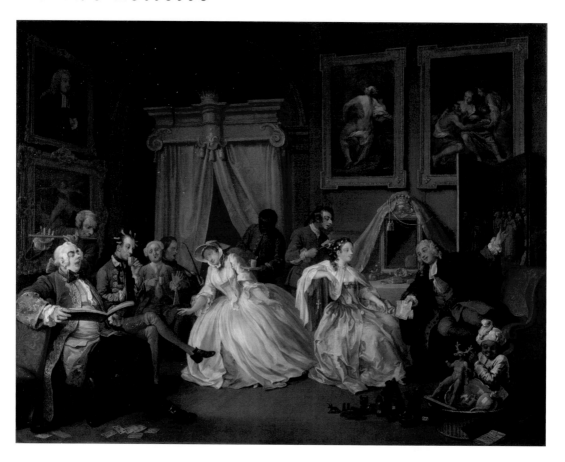

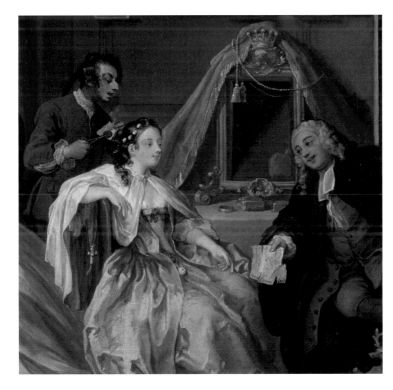

Three things in this room tell us that time has moved on, the Squanderfields have moved up and the 'intrigue' has progressed. First, an Earl's coronet at the top of a four-poster bed proclaims the fact that the Alderman's daughter is now the Countess Squander, and has inherited her late father-in-law's liking for status symbols. Second, she is now a mother: a teething-coral hanging from a red ribbon over her chair indicates that she sees the baby, occasionally, though we don't see it until the last scene. And thirdly, Silvertongue is now openly admitted to the house, at least by daylight, and demonstrates his privileges (and his lack of manners) by putting his feet up on the sofa.

The Countess is following the fashion set by the French court and aped by the London *beau*

monde of receiving visitors during the concluding stages of the *toilette* which follows her *levée* : that is, she has got up, and is now half-dressed (*en déshabille*), and is sufficiently presentable to receive visitors while her French hairdresser curls her hair (a little puff of smoke arises as he tests his curling tongs on paper). The implication is that she is now so much in demand in high society that this is the only moment when she can entertain the outer circle of her friends. On the floor in the left foreground is a careless scatter of cards, mostly invitations to card parties from the Countess's new acquaintances: Count Basset (who takes his name from a card game, but who is evidently either illiterate or a foreigner) *beg to no how Lade Squander Sleapt last nite*, Lady Heathan invites her to a Drum major 'next Sunday' (as only a 'Heathan' would), Miss Hairbrain to a Rout, Lady Townly to a Drum on Monday.[46] There are echoes here from Henry Fielding's play *The Modern Husband*, first performed in 1731:[47] Mrs Modern's engagement book reads 'Monday ... at Mrs. Squabble's; Tuesday, at Mrs Witless's; Wednesday, at Lady Matadore's; Thursday, at Mrs Fiddlefaddle's; Friday, at Mrs Ruin's; Saturday, at Lady Trifle's; Sunday, at Lady Barbara Pawnjewel's.'

The word *toilette* originally meant the little toile or piece of linen draped over the shoulders (as over the Countess's) while the hair was being dressed. By the 1740s, its meaning was extended to include the fashion for receiving visitors while completing one's dressing.[48] A toilette could also mean the 'toilet set' of silver brushes, tweezers, wig-powder shakers and boxes of paint, powders, patches and pomatums; elaborate (and costly) *toilettes* were designed by some of the finest silversmiths of the day. Some ladies needed a formidable battery of cosmetics, perfumes and unguents and several hours with which to make themselves up. Jonathan Swift's scabrous lines on *The Lady's Dressing Room*[49] begin:

> *Five hours, (and who can do it less in?)*
> *By haughty Celia spent in dressing ...*

And describes:

> *Gallipots and vials placed,*
> *Some filled with washes, some with paste;*
> *Some with pomatum, paints and slops,*
> *and ointments good for scabby chops ...*

Only the milder lines of Swift's poem are quoted here, as a reminder that Hogarth was not the only satirist in this period. The Countess is still young enough to get away with less repair work (fig. 25). We are not really surprised to see an Earl's coronet surmounting her silver-framed looking glass; nor are we surprised that it does not occur to the Countess to look at her own reflection in the glass, as more thoughtful ladies do in *vanitas* paintings. This foolish girl is so besotted that she has eyes and ears only for her silver-tongued lover lounging on the sofa.

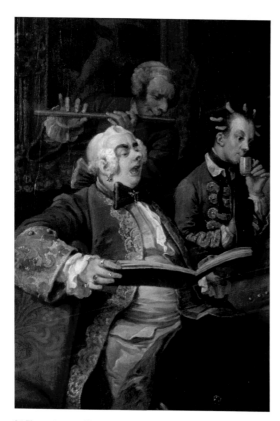

26 The castrato and his accompanist: detail from *The Toilette.*

Outwardly, this scene depicts a recital by an Italian singer whose beringed fingers, jewelled pendant, extravagantly curled wig and earrings indicate that he is a castrato (fig. 26). He has been variously indentified as Farinelli, Carestini (in fact not a castrato but a counter-tenor) or Senesino, each of whom had sung for several seasons in London opera houses during the previous decade.[50] All three had been idolised by audiences, but had returned to Italy in the mid-1730s, but others arrived to sing their roles, Handel's operas alone demanding castrati. The porcine features of Hogarth's castrato are closest to those of Senesino in engravings after Thomas Hudson and Joseph Groupy; but it is unlikely that Hogarth would have included a specific portrait of one individual in this series of invented characters; still more unlikely that either Farinelli, Carestini or Senesino would have deigned to sing at the Squanders' when they could command colossal fees in Covent Garden or the King's Theatre. Farinelli would not allow any of his singers to take outside engagements that would tire their voices. This castrato is probably a generalised portrait of the sort of 'foreigner' who (to Hogarth's disgust) took London by storm. He has probably brought his own accompanist with him, a vaguely Watteauesque flautist who adds yet another fashionably 'foreign' note to the scene.

A black manservant offers cups of chocolate while the castrato warbles on.[51] Only two people in the room appear to be listening to him. One, a woman in white, falls into a pantomime of rapture

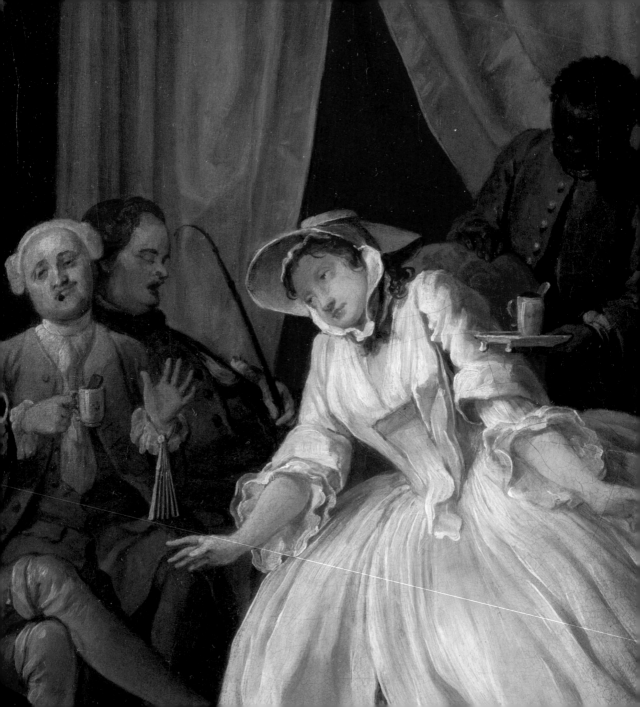

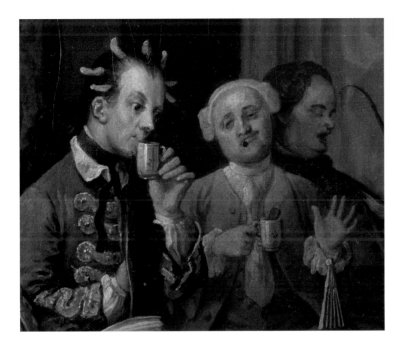

28 Audience reaction to the castrato: detail from *The Toilette*.

(fig. 27). The other, a man with a fan attached to his wrist, has the face of a toady, not improved by a black spot on his lower lip. Behind him, another man is frankly dozing. That leaves only a thin man with his hair in curl-papers, sipping chocolate with an abstracted air; evidently an *habitué*, possibly the dancing master, his turn to perform may come later (fig. 28).

As usual, the pictures add point and counterpoint to the story. On the wall behind the castrato is a version of Michelangelo's *Rape of Ganymede*; in Hogarth's version, the eagle's beak is dangerously lowered, as if one quick snap will result in castration if Ganymede resists. Hanging incongruously above the 'Michelangelo' is a recent portrait of Silvertongue, no less. On the wall behind the Countess's dressing table hang two utterly different images of sexual encounter: Io in ecstasy in the shadowy embrace of Jupiter disguised as a bear, after Correggio, side-by-side with Lot's daughters making their father drunk so that he will sleep with them and thus perpetuate the human

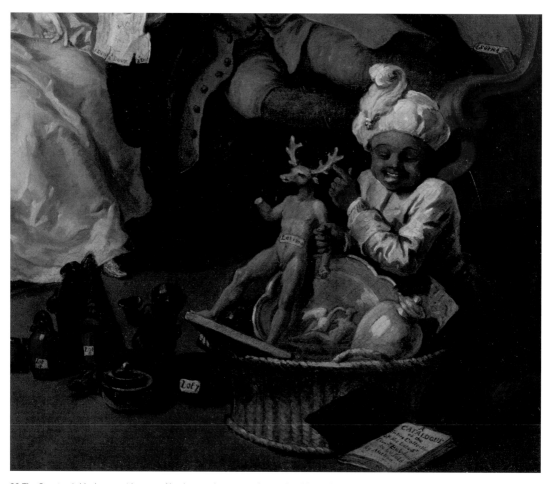

29 The Countess's black page with some of her latest saleroom purchases: detail from *The Toilette*.

race, after Caravaggio (?). But it is doubtful whether the Countess herself draws any conclusion from this contrast. Her most recent purchases, still bearing their lot numbers, have come from a sale whose catalogue lies on the floor (lettered *A CATALOGUE/of the/Entire Collection/of the Late S^r Tim^y Babyhouse/to be sold/by Auction*). Attending auction sales and being seen to bid extravagantly, frequently without previous viewing, demonstrated not only wealth but also the fashionable qualities of whim and caprice. The Countess's latest purchases are lined up as a parade of folly on the floor: more 'pagods', toads and *grotesqueries* and, in a basket, a silver platter embossed with a design of Leda and the Swan (yet another image of sexual encounter in disguise), inscribed *Iulio Romano*. The Countess may have taken a perverse pleasure in securing Lot 1000, a figure of *Actaeon*, whose horns can appropriately enough represent a cuckold, such as she has proved her husband to be. This image of the absent master of the house is causing the small black page some merriment (fig. 29).

The recital is after all only a diversion. The real action takes place on Silvertongue's side of the room. As if his attitude were not enough to inform us that his mind is not on the castrato, Hogarth tucks behind Silvertongue's feet a copy of *Le Sopha*, a collection by Crébillon *fils* of erotic tales reflecting the moral depravity of the day, and consequently a bestseller:[52] it was translated into English and published in London in 1742. Silvertongue takes advantage of the music to put a proposition to the Countess. With one hand he offers her a ticket for a masquerade; it is inscribed *1 Door 2d Door 3d Do..*, and we understand that if she can make her way to the masquerade, he will meet her inside. He gestures with his other hand towards a painted screen, on which Hogarth has depicted just such a masquerade in progress; in a large room lit by chandeliers, men and women wearing masks and disguises mingle more freely than they could do with propriety at a formal ball. Silvertongue indicates one of the foreground figures on the screen: it is a man dressed as a friar, conversing with a woman dressed as a nun.

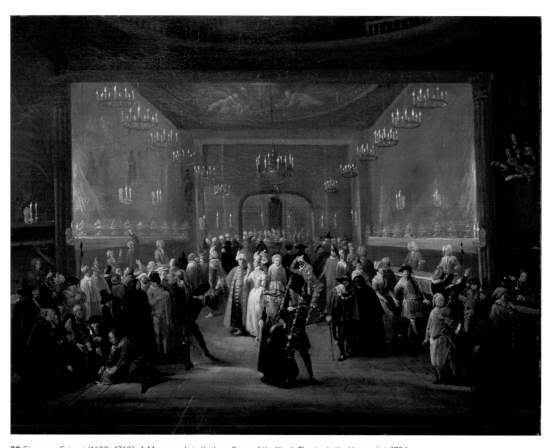

30 Giuseppe Grisoni (1699–1769), *A Masquerade in the Long Room of the King's Theatre in the Haymarket*, 1736.
Oil on canvas, 71 x 93 cm.
Victoria and Albert Museum, London, inv. P.22-1948.

Interlude: *The Masquerade*

A Masquerade in the Long Room of the King's Theatre in the Haymarket (fig. 30) is the most scintillating of several masquerade scenes by Giuseppe Grisoni (1699–1769), a Florentine working in London in the 1720s;[53] painted in 1736, less than ten years before *Marriage A-la-Mode*, it shows a masquerade in full swing.[54] This one is taking place in the Long Room which formed part of the King's Theatre. To boost the theatre's revenues the Swiss impresario Count John James Heidegger, manager of the theatre from 1708, staged masquerades there, some of which George I attended. As the century progressed, masquerades were also held in Vauxhall Gardens, Ranelagh Gardens, Carlisle House in Soho Square, and the Pantheon in Oxford Street (opened in 1772). But since Heidegger was the subject of his particular dislike, Hogarth probably had the King's Theatre in the Haymarket in mind when sending Silvertongue and the Countess off to a masquerade.

Contemporary descriptions of masquerades in the Haymarket suggest that Grisoni's picture is not fanciful. 'The room is exceedingly large, beautifully adorned and illuminated with 500 wax lights.' Two bands played, at either end of the room. 'The vast variety of dresses' gave an illusion of a congress of 'Turks, Italians, Indians, Polanders, Venetians, &c.' Masquerade costumes were specially made for the rich; for the less well-off, they could be hired by the night. Some were elaborate; but the more unimaginative (such as Silvertongue and the Countess) went as friars and nuns, in loose-fitting 'dominos'. As many as 700 people might attend a masquerade in the Haymarket, all wearing masks of one kind or another. Champagne and other wines were continually available from buffets at either side of the room. Supper was served at 11pm, 'the whole diversion continuing from nine o'clock till seven the next morning'.[55]

The Masquerade, A Poem, published anonymously (perhaps by Dr John Arbuthnot) in 1724 (price six-pence), hints at the amorous intrigues which could and did take place under the cover of masks and fancy dress:

> *The spacious* Dominoe *defies*
> *The cunning reach of jealous Eyes,*
> *Concealing Shape and Air;*
> *The Wife, before her Husband's Face,*
> *Might suffer her gallant's Embrace,*
> *Nor his resentment fear.*

The folly and potential immorality of masquerades were repeatedly attacked by satirists of the day, including Addison, Pope and Fielding; they also prompted denunciation by the Bishop of London in a *Sermon ... for the Reformation of Manners*, 1724. Hogarth's own method of satire took the form of engravings. In *Masquerades and Operas* (or *The Bad Taste of the Town*), published in 1724,[56] he charged Heidegger with debasing 'the English Stage'. Hogarth's *Masquerade Ticket* (fig. 31), published in 1727,[57] includes an altar to Priapus on the left, and on the right an altar to Venus. A pair of long-case

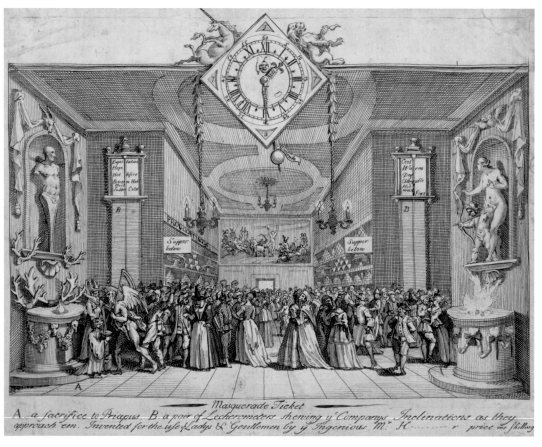

Masquerade Ticket

A a sacrifice to Priapus. B a pair of Lecherometers shewing y^e Companys Inclinations as they
approach 'em. Invented for the use of Ladys & Gentlemen by y^e Ingenious M^r H――――――r price in shilling

31 *Masquerade Ticket*, 1727.
Etching and engraving, 20.5 x 26.5 cm.
Andrew Edmunds, London.

'lecherometers' measure sexual appetites. Heidegger's bewigged head appears on the clock's face; its pendulum, inscribed *Nonsense*, moves incessantly, registering *Impertinence* every minute and *Wit* only once an hour.

The Masqueraders; or Fatal Curiosity, a deservedly forgotten novel published in two parts, 1725 and 1727, [58] may have given Hogarth the idea for the masquerade episode in *Marriage A-la-Mode*. Dorimenus, 'a passionate lover of intrigue' (and one who would have sent the 'lecherometer' soaring), gives a masquerade ticket to his latest love, Briscilla. 'She assured him she would appear in the Vestments of a *Nun*, and he, in conformity to her, would needs go as a Fryar.' When they left the masquerade, they proceeded to 'one of those Houses whose Dependance is on nightly Lodgers'. The plot of *The Masqueraders* may not be original. The novel is on the level of those satirised by the contemporary poet Mary Alcock in *A Receipt for Writing a Novel*:

> A masquerade, a murdered peer,
> His throat just cut from ear to ear,
> A rake turned hermit – a fond maid
> Run mad, by some false loon betrayed –
> These stores supply the female pen,
> Which writes them o'er and o'er again.
> And readers likewise may be found
> To circulate them round and round.

5: The Bagnio

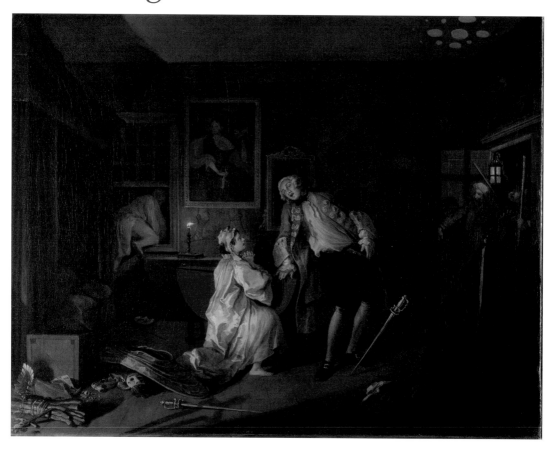

'Carry her to a bagnio, and there you may lodge with her', says Frankly to a would-be lover in Benjamin Hoadly's play *The Suspicious Husband*, 1747.[59] The word bagnio was first used in English of coffee-houses which were equipped with Turkish baths; by the 1740s it had come to signify a house which might advertise itself as offering Turkish baths but which chiefly provided rooms for the night with no questions asked, and would provide girls too if required. In *Night*, one of *The Four Times of the Day* sequence painted in about 1736 (fig. 32), Hogarth depicts the outside of two such dubious houses near Charing Cross; on one side of the street a sign is hung out reading *Bagnio*, on the other *The New Bagnio*. Very often, the sign of *The Turk's Head* was used as a euphemism instead. There were numerous *Turk's Heads* in London in the 1740,[60] some more respectable than others.

Scene 5 is set at night and by firelight, in a room in one of the less respectable bagnios. A crumpled bill lying on the floor (payment here is probably strictly in advance) is headed *The Bagnio*, with a picture of a Turk's head on it; probably the sign of *The Turk's Head* hangs outside the house. The chief piece of furniture is a bed. Two gate-legged tables by the wall suggest that the room can also be hired for gambling; but tonight they are folded, their services not required. Off-stage to the left, a fire must be burning low; we see only the long, slanting shadows cast by firelight.

Silvertongue and the Countess have come on from the masquerade to spend the night here.

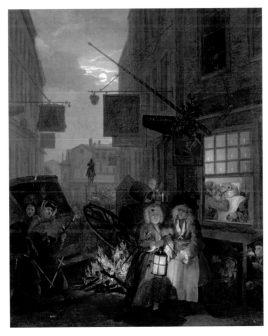

32 *Night,* from *The Four Times of Day,* about 1736.
Oil on canvas, 74 x 61 cm.
Bearsted Collection, Upton House, Warwickshire/The National Trust.

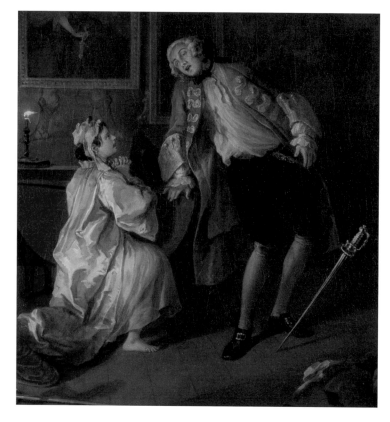

They have peeled off their dominoes and flung them on to a chair, and thrown aside their masks. The Countess's hooped underskirt lies like a half-collapsed Chinese paper lantern on the floor, beside her 'bearded lady' mask and her fashionable shoes with their upturned toes. She has tossed off her whaleboned stays with such abandon as to overturn a chair, and spill open the contents of a pill box. Her stays fall across a bundle of faggots, plausibly there as firewood, but in addition recalling that a 'faggot' was a low term for a harlot. The firelight is brightest in this

corner, casting coppery light and low shadows over this bizarre still life, which ends in the corner, with a pair of crossed sticks, the upper one red-hot at one end; hidden meanings are likely here, as well as the most obvious one that the situation is potentially disastrous. The bed is rumpled, and the candle has burnt low, though how long Silvertongue and the Countess have spent in the room is uncertain.

But their plans for a night of bliss in the bagnio have miscarried. The Earl himself has burst into the room. How he got there is anybody's guess. It is usually suggested that he followed them from the masquerade, bent on revenge, and challenged Silvertongue to a duel. But such positive, premeditated action would be out of character. It is just as likely – perhaps more likely, given the evidence of the Earl's nocturnal habits in Scene 2 – that this bagnio was one of his regular ports of call, and that some 'friend' tipped him the wink that his wife was in the next room. Such a scenario would be more in keeping with farces of the day. But this scene is not a farce. Things have gone seriously wrong, and will get worse. The Earl has burst the door open, knocking the lock off its hinges (it now lies on the floor). Perhaps he burst in with his sword already drawn, hoping to frighten Silvertongue or 'give him a lesson' (we saw him in Scene 3 brandishing his cane towards the doctor as if to exert his authority). But Silvertongue, again showing that capacity for effective action which the Earl lacks, reached for his own sword and used it

first, and to fatal effect. This surprise encounter is usually described as a duel, but wrongly: duels were arranged by protocol, requiring formal challenge, acceptance and the presence of seconds. Silvertongue's sword now lies near the Countess's hoops, stained with the Earl's blood. The Earl, who may well have drunk pretty deeply before having the courage to rush in to a confrontation, may have had no time to wield his sword before being fatally stabbed. Now it has dropped to the floor and become fixed there, point downwards, as impotent in action as the Earl himself has always been.[61]

The Countess falls on one knee beside the Earl, her hands clasped, a tear glistening on her cheek (fig. 33). Just what emotions possess her at this moment is impossible to say: perhaps a mixture of shock, horror, remorse and fear for her own future. Of all the six scenes, this one was the least carefully worked out in advance. Major alterations were made during the painting process, all of which are visible in X-rays and in an infra-red reflectogram.[62] Hogarth appears to have changed his mind completely over the part the Countess plays in the scene. Originally he depicted the figure of a loosely clad woman hurrying off to the left edge of the scene, seemingly aghast, and clutching a sword diagonally across her body, its hilt by her face; this figure was presumably Hogarth's first idea for the Countess, fleeing with the evidence of Silvertongue's guilt. He then painted out the figure, and placed the Countess kneeling at her husband's feet.

34 Still life with sword and shadow: detail from *The Bagnio.*

Hogarth's own indecision about how to stage this scene communicates itself to us: we are uncertain about how to react to it. The narrative line concerns death, desertion and despair; but there are too many burlesque elements in the scene for us to feel true concern for any of its characters. That may of course be precisely what Hogarth intended. On one level, the Countess kneeling before the dying Earl suggests remorse. On another level, it is pure theatrical parody: in innumerable plays and operas, the wife/daughter kneels before her husband/father, clasping her hands to beg forgiveness, protest her innocence or just gain time while a lover hides in a laundry basket.[63] In Hogarth's own paintings of *The Beggar's Opera* (first staged in the Lincoln's Inn Theatre in 1728), Polly Peachum kneels before her father and Lucy Lockit before hers, both hoping to save Macheath from hanging.[64]

But if the Countess's attitude is a theatrical cliché, the Earl's situation is more serious. Whether or not the Countess fully realises it, he has received a mortal wound. Hogarth depicts him in a slow dying fall, his long ungainly legs just beginning to cave in. If this were an opera, the slowness of his fall would give him ample time to sing a short aria (one hand on a table to support himself) before finally expiring. It has been suggested that the Earl's pose 'can only be an echo, and a conscious one, of a *Descent from the Cross*',[65] with the Countess in the pose of a Mary Magdalene, and the night watchman's lantern throwing the shadow of a cross on the door. If Hogarth borrowed ideas for the collapsing body of the Earl from some (unspecified) representation of the deposition of Christ's body from the cross, the Earl's own habitual physical awkwardness and the sheer theatricality of the pose are also elements in the result he achieved. Hogarth was certainly capable of deliberate irreverence; but he seems to have chosen to do no more here than to hint at a possible borrowing by throwing the shadow of a cross on the open door.

A more enigmatic shadow is thrown by firelight on the floor in the foreground. It is ostensibly the shadow of firetongs, which must be hanging up (Hogarth even includes the shadow of their hook) out of sight to our left (fig. 34). This shadow is very deliberately introduced; equally deliberately, Silvertongue's blood-stained sword is painted lying over it, as if thrusting through it. The shadow is perhaps also the schematic image of the long-legged man who is collapsing to the floor as we watch. The sword which mortally wounded him in the breast now lies, deeply stained with his blood, as if piercing the shadow through the groin. The sword alone has been able to 'cure' Lord Squander's venereal disease, at the cost of death. But there is probably a double meaning. In contemporary slang (then as now), a man's penis is his 'weapon'. Silvertongue's 'weapon' has reduced what is almost certainly the last of the Squanders to a shadow.

Predictably, the pictures on the walls are a bizarre assortment. A tapestry of *The Judgement of Solomon* hangs on the back wall, and a painting of

Saint Luke with his ox and ass above the door. Near the window hangs a wicked parody of the sort of 'Portrait of a Lady as a Shepherdess' painted by the fashionable portraitist Thomas Hudson, Hogarth's near-contemporary:[66] but this is the 'Portrait of a Harlot', who may have dressed for the masquerade as a shepherdess in a tilted hat, but who holds a squirrel (contemporary slang for a harlot) perched on one hand and, with the other, dangles the handle of (?) a parasol below her waist; since her portrait is hung over another picture in which we see only the legs of a man in buskins, the implications are lewd. The oddly angled gaze of the painted 'Lady' appears to be fixed upon the 'penitent' Countess, as if to suggest that they are each as bad as the other.

Between the painted Lady and the Countess, the candle flame veers wildly, blown between the draught from the open window and the open door. The proprietor of the *Turk's Head*, having heard a commotion, has summoned a constable, who carries his staff of office, and the night watchman, who holds his lantern high, its bars throwing the shadow of a cross on the door, its pattern of holes at the top casting pools of reflected light up to the ceiling (fig. 35). These three advance through the open door, Silvertongue has not a moment to lose; with one quick backward glance he makes what he hopes is his escape through the open window (fig. 36). He will drop into a street such as we saw in *Night* (fig. 32). In his nightshirt, and once the constable raises the alarm, he will not long escape arrest.

36 Silvertongue climbs out of the window: detail from *The Bagnio*.

6: The Lady's Death

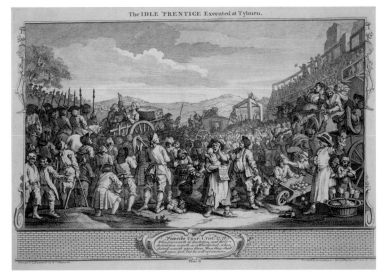

37 *The Idle 'Prentice Executed at Tyburn,* published in 1747.
Etching and engraving, 20.7 x 40.2 cm.
Andrew Edmunds, London.

Inscribed: *Design'd & Engrav'd by Wm Hogarth. Publish'd according to Act of Parliamt Sep. 30 1747.* Note the 'triple' tree, and the skeletons on the upper borders. Plate 11 of twelve plates of *Industry and Idleness.* From set published in Hogarth's lifetime.

In contrast to the first scene, which was set in the sumptuous house of a spendthrift, the last scene is set in the frugal house of a penny-pincher. The wretched Countess, dogged by the scandal following Silver-tongue's arrest, trial and sentence to death for the murder of her husband, has returned to the house of her father the Alderman. A newly printed broadsheet lettered *Counseller Silverton ... / last dying Speech* ... lies at her feet. On it is the image of Tyburn's 'triple tree', the three-sided gallows foreshadowed by the tripod in Scene 3. Like the condemned man in Plate 11 of *Industry and Idleness* (fig. 37) Silvertongue will have been taken in a cart

to Tyburn, but before being hanged from the triple tree, he will have been exhorted by a preacher to make a last speech from the scaffold professing repentance. The last speeches of condemned men, usually with macabre woodcut illustrations, were widely popular as reading-matter. The broadsheet is probably by now being hawked all over town.

With Silvertongue dead, the Countess thought only of suicide. She has drunk laudanum, probably the entire contents of the bottle now lying empty on the floor. Death appears to have come swiftly. She may not even have thought of her child, but an old nurse – perhaps the only character in the whole

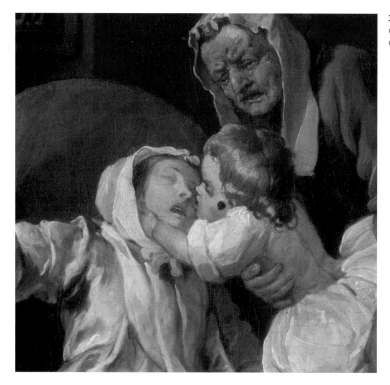

story who registers genuine emotion – lifts a child about two years old to kiss his or her mother (fig. 38). Whether the child is a girl or boy is left ambiguous (boys were dressed in long skirts until they were 'breeched' at about eight years old). What is all too clear is that the child has congenital syphilis to an advance degree. The black spot on its cheek and the sunken bridge of its nose are enough to indicate that; but as the child is lifted, we see also its pitiful legs, deformed by the disease (like the doctor's, in Scene 3), and encased in surgical boots and braces. The black spot on the cheek may suggest that this is the Earl's child; but the Earl will have passed on the infection to his wife, and the child's parentage remains in question. This group of mother, nurse and child parodies the final scene

in many a novel of virtue rewarded. Above all, it is a parody of Samuel Richardson's novel *Pamela* (then much-acclaimed, but to many – including Fielding – tedious) which Hogarth had been invited to illustrate, though not finally employed to do so. Gravelot's illustration of the virtuous Pamela who, after strenuously defending her honour throughout 103 'Letters', is rewarded at the end by marriage and a bouncing baby, is reproduced here (fig. 39). The Countess has not been so careful, nor so lucky. The child, an innocent in this story, has not been lucky at all. Not only is it hopelessly diseased, but it is now an orphan, in the comfortless house of its parsimonious grandfather; he was indifferent to his daughter's happiness, and we see in this scene how he treats the household dog. The crippled child is not likely to survive long.

On the left, the Alderman removes a ring from the finger of his dying daughter (fig. 40); suicide's chattels were forfeit. He is dressed exactly as he was in Scene 1; he was never a man of fashion. Nor is he a man of taste. The pictures in his house are all of the Dutch low-life school: pictures with broad bourgeois jokes, such as a man urinating against a wall (near the clock), a ham skewered by a rapier in the pile-up of food next to it, or a drunkard lighting his pipe at another's nose (on the left).

The room is sparsely furnished; it contains little of comfort, and the boards are bare. A plain old-fashioned clock hangs on the wall. The Alderman does not spend money on whims. His wealth is not displayed; but we can be sure that it

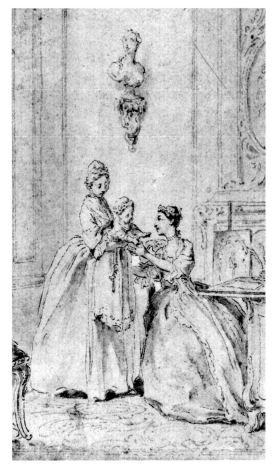

39 Hubert-François Bourgignon Gravelot (1690–1773), 'Billy is brought into my Presence, all smiling'. Illustration for *Pamela* by Samuel Richardson, 3rd ed. 1742.
Pen, ink and sepia wash, 12.8 x 7.6 cm.
Private collection.

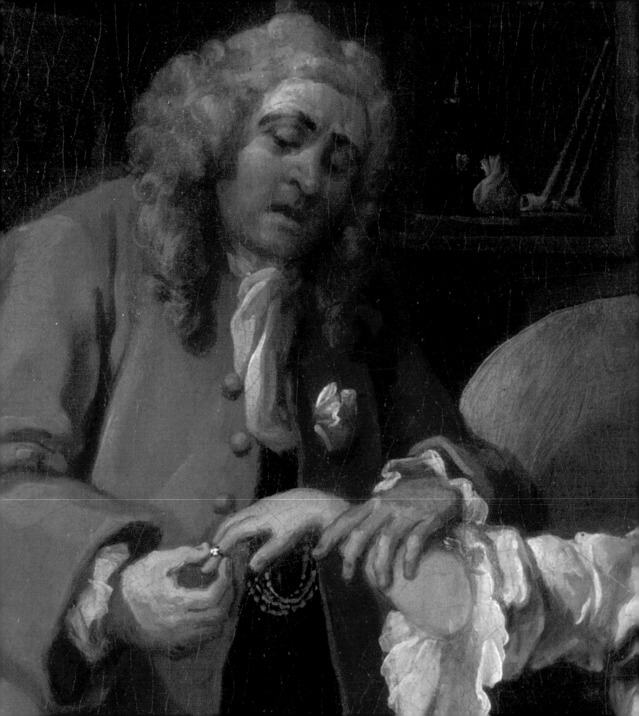

is measured and accounted for, down to the last groat. He has unlocked the door of a corner cupboard, presumably to stow away his daughter's ring; in it we see his ledgers, his most important possessions. Even within the cupboard, the ledgers are turned back to front, less anyone should spy on the evidence of his wealth.

The Alderman's civic gown and hat hang by the clock, and a silver punch bowl lends a solitary note of splendour to the table – but that was probably presented to him after a period of office rather than purchased by him. An open window reveals a view of London Bridge, at that date still with houses on it. We are somewhere in the City of London, probably near Blackfriars Bridge. Having been unwillingly married from her father's house, the Countess had probably never revisited it until now. Perhaps the cruellest thing about her appearance as death approaches is the way her toes turn up within shoes designed for frivolity: she wore similar shoes in Scene 2, and appears to have worn them (and quickly discarded them) to the masquerade which was to have ended so blissfully. Now what was once high fashion simply expresses the onset of *rigor mortis*.

A doctor has been called: but there is nothing he can do, and he wanders off behind the Alderman, appearing to admire his fire precautions (a row of buckets lettered S, presumably for *Sand*). All we see of him is the back of his full wig and the top of his gold-handled cane. More in evidence is the apothecary, to the right of the Countess, with a nosegay in his buttonhole to counteract the odours in which he has to move, and what looks like the top of a stomach pump and a bottle of julep in his pocket. He is making a great show of accusing a half-witted servant of procuring the Countess's fatal draught of laudanum; but it is possible that the apothecary was himself treating the Countess with laudanum for a sexual infection (or for countering the adverse effects of mercurial pills), and now fears blame because she has drunk the lot. The servant is not certainly guilty. Clad in some cast-off of the pale-green livery which we saw the old Earl's servants wearing in the courtyard in Scene 1, his hair in curlers in a vain attempt to keep up something of the old style, he is perhaps the only one loyal enough to have remained in the Countess's employment.

A table by the window is laid with the Alderman's next meal (fig. 41). It is breakfast for a skinflint. A boiled egg is upright in a dish of rice ('It is hard to shave an egg': old proverb). A starved dog is about to make off with a pig's head whose upturned snout and closed eyes bear a ghoulish resemblance to the face of the dying Countess across the room. This still life on a round table covered with a white cloth may be a deliberate parody of Chardin – for instance of *The White Tablecloth* of 1731/2 (fig. 42) – whose work Hogarth might have seen in Paris in 1743.

So the tragic-comedy ends. The black spots of venereal disease have run like a dark thread

41 The Alderman's table: detail from *The Lady's Death.*

throughout its scenes; but the target is not the prevalence of disease but the want of morals. Without morality, heartlessness takes over, in its varying forms of lust, greed and self-interest. Sexual immorality is only one of these. The antics in *The Bagnio* remain faintly farcical, even though a man dies before our eyes. True heartlessness is reserved for the last scene of all. As his grandchild embraces its mother with instinctive tenderness, the Alderman denies his dying daughter her chance to return the embrace, grabbing her arm for the sake of the ring on her finger. Though he is largely responsible for what has happened, he has learnt nothing whatsoever from the dark story which has been played out.

42 Jean-Siméon Chardin (1699–1779), *The White Tablecloth*, about 1731–2.
Oil on canvas, 96.6 x 123.5 cm.
The Art Institute of Chicago, Illinois, Mr. and Mrs. Lewis Larned Coburn Memorial Collection, 1944.699.

Engraving *Marriage A-la-Mode*

On 2 April 1743, Hogarth inserted the following advertisement in *The London Daily Post and General Advertiser*:

> MR HOGARTH intends to publish by subscription, SIX PRINTS from Copper-Plates, engrav'd by the best Masters in Paris, after his own Paintings; representing a Variety of *Modern Occurrences* in *High-Life*, and called MARRIAGE A-LA-MODE.
>
> Particular Care will be taken, that there may not be the least Objection to the Decency or Elegancy of the whole Work, and that none of the Characters represented shall be personal.
>
> The Subscription will be One Guinea, Half to be paid on Subscribing, and the other half on the Delivery of the Prints, which will be with all possible Speed, the Author being determin'd to engage in no other Work till this is completed...[67]

At the end of May 1743, Hogarth made a trip to Paris, about which little is known[68] apart from what he relates in a further advertisement for the engravings on 8 November 1744,[69] some eighteen months later. There he states that the purpose of his trip was to commission six French engravers to work in Paris on one plate of *Marriage A-la-Mode*, but his plans were thwarted by political tension between England and France.

Hogarth did not in fact have to look further than London for highly skilled French engravers; and in the end he commissioned Bernard Baron, Gérard Jean-Baptiste Scotin and Simon-François Ravenet each to engrave two plates. All three had been born and trained in France, and all three had engraved '*galant*' subjects after Watteau. Baron and Scotin had settled in London at least a decade earlier, and both had already worked for Hogarth. Ravenet may have come from Paris partly at Hogarth's invitation, but had worked in London before and was also working for Hayman (on *Fables for the Female Sex*, published in 1744).

Baron, Scotin and Revenet, each of them more or less the age of Hogarth himself, made a thoroughly professional team, working under Hogarth's close supervision. They probably began work in May or June 1743. On 29 December 1744 Hogarth announced in the *London Evening Post* that 'The Plates call'd *Marriage-A-La-Mode*, are in great forwardness, and will be ready to deliver to Subscribers on or near Lady-Day next [25 March]'. Each plate is dated 1 April 1745; the set was probably finally ready by the end of May 1745.

Bernard Baron (?1696–1766), who engraved Plates II and III of *Marriage A-la-Mode*, was at the top of his profession.[70] He had worked regularly for Watteau (engraving *L'Accord Parfait*, *L'Amour Paisible* and *Les Comédiens Italiens*, among others), and may be subject of Watteau's beautifully observed red chalk drawing, *An Engraver (Bernard Baron?) working at his Table* (fig. 43). Hugh Howard, artist and collector (died 1737), who owned the

drawing, identified it as 'M. Baron, the graver' on an old mount, now lost, and so a question mark has hung over the identification. Whether or not it is of Baron, this is an informative study of an engraver at work. Seated at a work-table directly under a skylight, the image he is translating into line propped up before him, he is absorbed in incising its details on the copper plate, perhaps working over an already etched outline. The (unseen) tool in his right hand is probably a burin (also known as a graver), which is used by pushing it forward through the metal plate. Other engraving tools (mostly burnishers, to keep the lines sharp) are at hand on his table. Hatching and cross-hatching will add half-tones, grey tints and shadows to the engraved outline. The image he is working from may be a squared drawing, an intermediary stage which helps the engraver to concentrate on small areas of the work. Squared drawings for Plates II and III of *Marriage A-la-Mode* survive (fig. 44); the same size as the engravings, they were almost certainly made by Baron himself.[71] Reproductive engravers (those commissioned to reproduce a painting or drawing, as distinct from those who create an original image on a plate) usually engrave the image as they confront it; thus when their plates are printed onto paper, the image appears in reverse (fig. 44 and 45).[72]

43 Jean-Antoine Watteau (1684–1721), *An Engraver (Bernard Baron?) working at his Table*, about 1720.
Red chalk, 23.5 x 30.4 cm.
The British Museum, London. Inv. 1874.0808.2279.

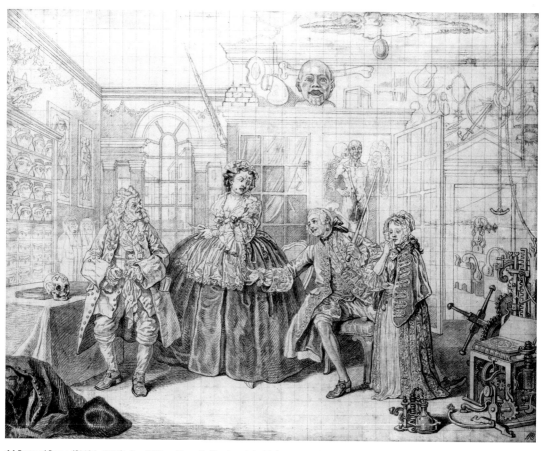

44 Bernard Baron (?1696–1766) after William Hogarth, *Marriage A-la-Mode scene 3: The Inspection*.
Red chalk on paper, squared, 35.7 x 45.8 cm.
The Royal Collection, inv. RL 13493.

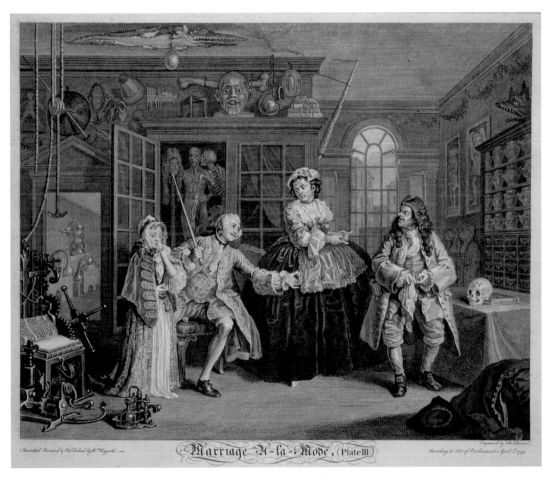

45 Bernard Baron (?1696–1766) after William Hogarth, *Marriage A-la-Mode scene 3: The Inspection.*
Etching and engraving, 38.5 x 46.5 cm.
Andrew Edmunds, London.

Selling the Paintings of
Marriage A-la-Mode

In 1751 Hogarth offered the paintings of *Marriage A-la-Mode* for sale 'to the Highest Bidder', by a system of written bids. The highest bidder by twelve noon on 6 June 1751 would be the buyer. The result was cruelly disappointing. Early that day Hogarth 'dressed himself, put on his tye-wig, strutted away one hour, and fretted away two more'. Only one written bid had been made, for £120 for the set of six paintings. Only one visitor attended the house that morning, a seemingly unknown admirer called John Lane.[73] He offered an advance on the single written bid by making by making 'the pounds guineas' (£126). When the clock struck twelve, Hogarth 'wished Mr Lane joy of his purchase'; but his chagrin was so evident that Mr Lane generously offered him three more hours in which to find a better purchaser. Hogarth waited only one further hour. At 1pm he declared Lane to be the outright purchaser.

The paintings of *Marriage A-la-Mode* remained with John Lane, who steadfastly refused all offers for them, until his death in 1791. He bequeathed them, with all his property, to Colonel John Fenton Cawthorne MP, perhaps a godson, certainly a spendthrift and a swindler (court-martialled for embezzlement in 1796 and expelled from the House of Commons), and as unlike Lane himself as any heir in a Hogarthian modern moral subject. Cawthorne offered them for sale at Christie's on 10 March 1792, but they were bought in at 910 guineas. Subsequently he mortgaged them to a Mr Holmes, by whom (presumably) they were sold at Christie's on 10 February 1797. This time they made what was probably the reserve price of 1,000 guineas. They were bought by John Julius Angerstein, a great admirer of Hogarth. After his death in 1823, they were purchased with the Angerstein collection for the nation. They were exhibited for the first time when the new National Gallery opened its doors in May 1824.

Select Bibliography

David Bindman — *Hogarth*, London 1981

David Bomford and Ashok Roy — 'Hogarth's *Marriage A-la-Mode*', *National Gallery Technical Bulletin*, 6, 1982, pp. 45–67

Robert L.S. Cowley — *Marriage A-la-Mode: A Re-view of Hogarth's Narrative Art*, Manchester 1983

Martin Davies — *National Gallery Catalogues: The British School*, London 1959, pp. 48–68

Judy Egerton — *National Gallery Catalogues: The British School*, London 1998

Lawrence Gowing — *Hogarth*, exh. cat. (Tate Gallery) London 1971

Michael Levey — '*Marriage A-la-Mode*' by William Hogarth, National Gallery, London 1970

Robert Etheridge Moore — *Hogarth's Literary Relationships*, Minneapolis 1948

Ronald Paulson — *Hogarth: His Life, Art and Times*, 2 vols, New Haven and London 1971

Ronald Paulson — *Hogarth's Graphic Works*, London 1989

Ronald Paulson — *Hogarth*, 3 vols, New Brunswick 1991–3

André Rouquet — *Lettres de Monsieur ** à un de ses Amis à Paris, Pour lui expliquer les Estampes de Monsieur Hogarth*, London 1746

Sean Shesgreen — *Engravings by Hogarth: 101 Prints*, New York 1973

F.G. Stephens — *Catalogue of Prints and Drawings in the British Museum: Division 1. Political and Personal Satires*, vol. III, Part 1, cats. 2688, 2702, 2717, 2731, 2744, 2758

Horace Walpole — *Anecdotes of Paintings in England*, vol. IV, 1780; ed. James Dallaway, London 1827, pp. 126–49

Mary Webster — *Hogarth*, London 1978

Notes

1 See p. 51; and see Ronald Paulson, *Hogarth's Graphic Works*, London 1989, pp. 47–9, cat. no. 44, repr. p. 230.

2 Ellis Waterhouse, *Painting in Britain 1530–1790*, Harmondsworth 1953, edn 1962, p. 118.

3 George Vertue, 'Vertue Notebooks', vol. III, Walpole Society, 1934, p. 41.

4 Ed. Joseph Burke, *William Hogarth: The Analysis of Beauty ... and Autobiographical Notes*, Oxford 1955, p. 216.

5 There are of course precedents for some aspects of Hogarth's 'new' form of art in an old tradition (Italian and Dutch as well as English) of popular engravings of a satirical or moralising nature.

6 'Vertue Notebooks' (cited in note 3), p. 58.

7 Horace Walpole, *Anecdotes of Painting in England*, 1780, ed. James Dallaway, vol. IV, London 1827, p. 140.

8 Henry Fielding, Preface to *The History of the Adventures of Joseph Andrews, and of his friend Mr Abraham Adams*, London 1742.

9 Probably the most recent reproductions are in ed. Sean Shesgreen, *Engravings by Hogarth: 101 Prints*, New York 1973.

10 Waterhouse (cited in note 2) described Scene 2 as 'one of the most captivatingly lovely paintings of the English school', p. 122.

11 'Vertue Notebooks' (cited in note 3), p. 156.

12 Henry Fielding's phrase of his own depiction of human nature, which he will at times 'hash and ragoo ... with all high French and Italian seasoning of affection' (Introduction to *Tom Jones*, 1749).

13 *Anecdotes of Painting* (cited in note 7), vol. IV, p. 132.

14 See Paulson 1989 (cited in note 1), cat. no. 156, pp. 63–4, repr. p. 339. For the *'Difference Betwixt Character & Caricatura'*, Hogarth refers readers (at the bottom of the print) to Henry Fielding's Preface to his novel *Joseph Andrews* (1742, cited in note 8). There Fielding writes that the aim of caricature 'is to exhibit Monsters, not men; and all distortions and Exaggerations whatever are within its proper Province'. In Hogarth's works, by contrast, Fielding sees 'the exactest Copy of Nature'.

15 William Hogarth, 'Apology for Painters', MS (British Museum Add. MS 27,993), ed. Michael Kitson, *Walpole Society*, vol. XLI, 1968, lines 305–6.

16 Eric Partridge, *Dictionary of Historical Slang*, London 1972, p. 566, dating the expression to 'mid 18thc'.

17 *Anecdotes of Painting* (cited in note 7), vol. IV, p. 135.

18 André Rouquet, *Lettres de Monsieur ** à un de ses Amis à Paris*, London 1746, p. 30.

19 Colman and Garrick, *The Clandestine Marriage* (cited under note 25), p. 705.

20 Thomas Fuller, *Gnomologia*, 1732, p. 14, no. 350.

21 Viscount Squanderfield is a courtesy title borne by the son of the Earl of Squander; when his father dies, the Viscount will succeed him as the next Earl of Squander. See Davies 1959, pp. 57–8, note 26.

22 The author is indebted to Dr Adam Lawrence, Head Physician in Genitourinary Medicine, Chelsea and Westminster Hospital, Fulham, London, for his observations (in a series of discussions) on the large extent to which *Marriage A-la-Mode* is concerned with venereal disease. It has long been recognised that the disease plays some part in the story. Dr Lawrence is the first to observe its full incidence, and the first to perceive that the 'black spots' which figure so conspicuously in Hogarth's imagery are the symbols of the black mercurial pills which were at that time the most common form of treatment of the disease. Dr Lawrence bases this perception on his knowledge of the medical practice and mercurial prescriptions of John Hunter FRS (1728–1793), as recorded in his *Casebooks* (ed. E. Allen, J.L. Turk and Sir R. Murley, London 1993).

23 *Anecdotes of Painting* (cited in note 7), vol. IV, p. 126.

24 Fuller, 1732 (cited in note 20), p. 86, no. 2149.

25 George Colman senior and David Garrick, *The Clandestine Marriage*, first produced at Covent Garden Theatre 1766, as published in ed. Cecil A.

Moore, *Plays of the Restoration and Eighteenth Century*, New York 1933, p. 663.

26 See Martin Davies, *National Gallery Catalogues: The British School*, London 1959, p. 59, n. 14.

27 Edmond Hoyle (1672–1769), *A Short Treatise on Whist*, first published 1742: the presence of this book in the scene helps to establish the date of the painting as (probably) 1743.

28 In *The Assembly at Wanstead House*, 1730–1, Hogarth ironically introduced a 'carved' portrait of William Kent into the right side of the chimneypiece. The painting is now in the Philadelphia Museum of Art; see Richard Dorment, *British Paintings in the Philadelphia Museum of Art*, Philadelphia 1986, p. 159, repr.

29 Its first verses are given in Thomas D'Urfey, *Wit and Mirth: or Pills to Purge Melancholy*, London 1719, vol. IV, p. 310, with a tune (by John Barrett) used by John Gay for song no. LVIII in *The Beggar's Opera*.

30 William Hogarth, *The Analysis of Beauty*, ed. Joseph Burke, Oxford 1955, p. 50.

31 Hugh Honour, *Chinoiserie*, London 1961, p. 53.

32 Hogarth, Preface to *The Analysis of Beauty* (cited in note 30), p. 17.

33 In the engraving, where the painting's date would be irrelevant, the paper is more precisely inscribed 'Rec[d] June 4 1744'.

34 See ' "Two minutes with Venus, two years with mercury": Mercury as an antisyphilitic chemo-therapeutic agent', *Journal of the Royal Society of Medicine*, vol. 83 (6), 1990, pp. 392–5.

35 The author's debt to Dr Adam Lawrence, gratefully acknowledged in note 22, extends to his advice to study John Hunter's *Casebooks* and also R.S. Morton, 'Syphilis in art: an entertainment in four parts. Part 3: The Seventeenth and Eighteenth Centuries', in *Genitourinary Medicine*, published by the British Medical Association, London, June 1990, vol. 66, no. 3. See also N.F. Lowe, 'Hogarth, Beauty Spots and Sexually Transmitted Diseases', *British Journal for Eighteenth-Century Studies*, vol. 15, no. 1, 1992.

36 Dr Lawrence observes that the doctor's profile may be compared with plate 95 in A. King, C. Nicol and P. Rodin, *Venereal Diseases*,

London 1980, and that the deformity of his legs indicates syphilitic osteoperiostitis of the tibiæ; he draws attention to plate 58 of King, Nicol and Rodin 1980. See also Morton 1990 (cited in note 35) p. 216; He reproduces Lairesse's self portrait of about 1675, now in the Uffizi, Florence (his p. 209).

37 For various interpretations of the letters, see Paulson 1989 (cited in note 1), p. 119.

38 'As is the mother, so is her daughter'; Book of Ezekiel, 16: 44.

39 This is a common nickname for a doctor, especially one treating patients with mercurial pills for venereal disease.

40 For Dr Richard Mead (1673–1753), see *Dictionary of National Biography*. His portrait by Allan Ramsay, dated 1747, is coll. Thomas Coram Foundation for Children, repr. in colour in Elizabeth Einberg, *Manners and Morals*, exh. cat., (Tate Gallery) London 1987, p. 176. Dr Mead's sale was conducted by Mr Langford, Covent Garden, 11–15 March 1755.

41 The two paintings ?given/bequeathed to him by Antoine Watteau are *French Comedians* and *Italian Comedians*.

42 William Schupbach, Curator of the Iconological Collections, Wellcome Institute for the History of Medicine, in correspondence.

43 Is Hogarth's scene the source of the phrase 'a skeleton in the cupboard'? The *Oxford English Dictionary* gives the earliest usage of the phrase (as meaning 'a source of shame') as by Thackeray, in 1845, but notes that 'it is known to have been current at an earlier date'.

44 It has often been suggested that this face is that of Dr Misaubin. A near-caricature sketch by Watteau which was engraved by Arthur Pond in 1739, and lettered *Prenez des Pilules, prenez des Pilules* (E. de Goncourt, 1875, p. 36, no. 26) is thought to portray Dr Misaubin, who was famous for 'pillules' to treat venereal disease.

45 Henry Fielding, *The Mock Doctor or, The Dumb Lady Cured. A Comedy done from Molière. As it was acted at the Theatre Royal in Drury Lane*, 1732. Reprinted in *Dramatic Works by Henry Fielding Esq.*, vol. II, London 1882.

46 A 'drum' was an evening party; a 'drum major' a large evening party; a 'rout' was a

particularly large (and probably late) evening party.

47 *The Modern Husband, A Comedy, as it was acted at the Theatre Royal in Drury Lane, 1731*, reprinted in *Dramatic Works by Henry Fielding Esq.*, vol. II, London 1882; the quotation is from scene ii, p. 78.

48 This is also how Jonathan Swift uses it (though he anglicises *toilette* to 'toilet') in *Cadenus and Vanessa*, in a long passage about female diversions: ' … Every trifle that Employs/ The out or inside of their heads/Between their toilets and their beds.' See *Jonathan Swift, The Complete Poems*, ed. Pat Rogers, New Haven and London 1983, pp. 131, 139.

49 See *Jonathan Swift: The Complete Poems*, op. cit., p. 448, lines 1–2; p. 449, lines 33–7. See note p. 827. This devastating poem was one of the most popular in Swift's lifetime; seemingly first printed in 1732, it went through a whole range of editions in England and Ireland.

50 See P.H. Highfill, K.A. Burnim and E.A. Langhans, *A Biographical Dictionary of Actors, Actresses, Musicians, Dancers, Managers & other Stage Personnel in London, 1660–1800*, Illinois, 16 vols, 1968–94: (1) for Farinelli (the stage name of Carlo Broschi), vol. V, pp. 145–52; (2) Giovanni Carestini, vol. V, pp. 57–9; (3) for Senesino (stage name of Francesco Bernardi), vol. XIII, pp. 249–55.

51 David Dabydeen, *Hogarth's Blacks: Images of Blacks in Eighteenth-Century Art*, Athens, Georgia, 1987 suggests (p. 76) that the black manservant 'is a symbol of the type of hottentot fertility that is lacking in the white Opera singer. His coarse, natural, paw-like fingers are deliberately depicted in contrast to the bejewelled, effeminate fingers of [?] Senesino. His type of sexuality plays an intricate part in the network of sexual innuendos in the picture.'

52 Claude-Prosper Jolyot de Crébillon (1707–1777). *The Sopha. A Moral Tale* was listed in *The Gentleman's Magazine*, May 1842, p. 280: 'Register of Books for May 1742', no. 40, price three shillings.

53 For Grisoni, see Edward Croft-Murray, *Decorative Painting in England 1537–1837*, London 1970, pp. 214–15. A different *Masquerade on the Stage of the King's Theatre in the*

Haymarket, 'perhaps by Giuseppe Grisoni', is repr. Croft-Murray and Phillips 1949 (cited below in note 54), p. 673, then coll. Sir Osbert Sitwell.

54 For the general subject of masquerades, see Edward Croft-Murray and Hugh Phillips, 'The Whole Humours of a Masquerade', *Country Life*, 2 September 1949, pp. 672–5. For masquerade dress, see Aileen Ribeiro, *The Dress worn at Masquerades in England, 1730 to 1790, and its Relation to Fancy Dress in Portaiture*, PhD dissertation, New York and London 1984. See also Terry Castle, *Masquerades and Civilization*, Stanford 1986.

55 Most of this information is from a report in Mist's *Weekly Journal* for 15 February 1718, quoted by Croft-Murray and Phillips 1949, cited in note 54.

56 Fully described and discussed by Paulson 1989 (cited in note 1), pp. 47–8, cat. no. 44, repr. p. 230.

57 Fully described and discussed by Paulson 1989 (cited in note 1), pp. 70–1, cat. no. 108, repr. 277.

58 The full title is *The Masqueraders; or Fatal Curiosity: being the Secret History of a Late Amour*, published by J. Roberts in two parts, 1725 (4th edition) and 1727. Quotations are from Part 2, pp. 8 and 27.

59 First performed at Covent Garden on 12 February 1747, with David Garrick as Ranger. For the text, see ed. Mrs Inchbald, *The British Theatre*, vol. XIX, 1824; the quotation is from Act II, Scene iv, p. 35.

60 See Bryant Lillywhite, *London Coffee-Houses*, London 1963, pp. 602–17.

61 The broken-off right hand of the figure of Actaeon in Scene 4, among the junk the Countess purchased in an auction sale, may presage this inability to defend himself.

62 See David Bomford and Ashok Roy, 'Hogarth's *Marriage A-La-Mode*', *National Gallery Technical Bulletin*, 6, 1982, pp. 45–68.

63 The latter scene, as staged in David Lingelbach's popular comedy *Pretended Virtue Exposed* (1687), was depicted in 1743 and again in 1739 by Hogarth's Dutch contemporary

Cornelis Troost (1696–1750), who was closely involved with the theatre of his day. See *Cornelis Troost and the Theatre of his Time*, exh. cat., (Mauritshuis), The Hague 1993 (8 and 9, both repr.).

64 Hogarth's first version of *The Beggar's Opera* is in Tate Britain; see E. Einberg and J. Egerton, *Tate Gallery Collections, Vol. II: The Age of Hogarth*, London 1988, repr. p. 77; at least four other versions are known (see pp. 78–80).

65 Ronald Paulson, *Hogarth: His Life, Art and Times*, New Haven and London 1971, p. 486.

66 See *Thomas Hudson 1701–1779*, exh. cat. (Iveagh Bequest, Kenwood) 1979, e.g. Mary Carew, engraving, ? 1741 (10, repr.).

67 The advertisement concludes by announcing that the price will be one and a half guineas after the subscription closes, and adds that no copies will be made of the prints.

68 Vertue notes '<May ultimo> [1743] Mr Hogarth is set out for Paris – to cultivate knowledge or improve his Stock of Ass[urance]'; 'Vertue Notebooks' (cited in note 3), p. 116. Anita Brookner (*Greuze*, London 1972, p. 47) notes that Hogarth's visit to France in 1743 has never been the subject of 'rigorous and searching enquiry'.

69 In the *Daily Advertiser*, 8 November 1744.

70 Baron is included in the group portrait by Gawen Hamilton, 1735, known as *A Conversation of Virtuosis ... at the King's Arms*, now in the National Portrait Gallery, London (1384); see John Kerslake, *Early Georgian Portraits*, National Portrait Gallery, London 1977, pp. 340–2, plate 951.

71 See A.P. Oppé, *English Drawings, Stuart and Georgian Periods ... at Windsor Castle*, London 1950, p. 66, cats. 362–3. No. 362 is a similar chalk drawing for Plate 2.

72 Paulson 1989 (cited in note 1), p. 6, maintains that Hogarth 'always painted with the general structure of the engravings in mind', and that the 'reading structure is embodied in the engraving, not in the painting'. From this it would follow that Hogarth deliberately designed the *Marriage A-la-Mode* series of paintings in reverse, so that the prints would correctly reflect his concept of their 'reading structure': e.g. that he intended the Earl in Scene 1 to be seated on the left, not the right; the steward in Scene 2 to exit on the right, not the left, etc. This theory has not so far been supported by other Hogarth scholars.

73 Lane's MS account of the sale is among the Nichols Papers, National Portrait Gallery Archives; edited and published by John Nichols, *Biographical Anecdotes of William Hogarth*, 1781, pp. 107 ff.

Picture Credits

DVD

Enjoy Alan Bennett's lively commentary of William Hogarth's *Marriage A-la-Mode* series with this free DVD.

Running time approx. 40 minutes

Region free • widescreen • English subtitles